STEAM IN SCOTLAND

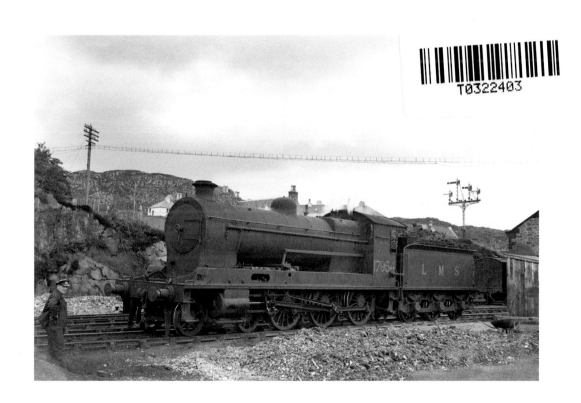

ABOUT THE PHOTOGRAPHER

R.J. (Ron) Buckley was born in 1917 and after the family moved to a house overlooking Spring Road station, near Tyseley, in 1926, his interest in railways grew. Joining the Birmingham Locomotive Club in 1932 he made frequent trips with them throughout the country, also accompanying W.A. Camwell on his many branch-line tours. From 1935 until 1939 these club tours included Scotland, where he photographed many examples of the rare pre-grouping company locomotive classes still in existence throughout that country. In 1934 he joined the London Midland and Scottish Railway (LM&SR) as a wages clerk at Lawley Street goods station, Birmingham, and after the declaration of war in September 1939 was called up and joined the Royal Engineers, being posted to the No. 4 Dock Operating Unit. Serving briefly in Norway during March 1940, he was by May of that year with a special party supplying stores for the returning troops at Dunkirk. Ron was evacuated from Dunkirk on the *Maid of Orleans*, an ex-Southern Railway cross-Channel ferry, and by 1941 he was in Egypt with his unit supporting the 8th Army in its advance from Alamein to Tripoli. The year 1944 saw his unit in Alexandria before his return to Britain during 1945 and demob in May the following year. His employment continued with the LM&SR; he was based at Kings Heath in Birmingham and at Derby in the British Railways Divisional Managers' Office from 1948. He witnessed the continual stream of locomotives passing through the works and photographed many of the new British Railway Standard locomotives constructed there. Further visits to Scotland in 1946, 1950 and 1959 gave him the opportunity to observe the changes that had taken place in locomotive power in that country. Married in 1948 to Joyce, the daughter of a London and North Eastern Railway (LNER) locomotive driver, they toured Scotland together on several occasions, with Ron retiring in 1977 after over forty-two years' service with the railways. He and his wife currently live in Staffordshire.

DEDICATION

This book is dedicated to the photographer's long-suffering wife Joyce, without whose unfailing support and understanding of his absences on many tours around the country a large amount of his photographic collection would not have been accumulated.

STEAM IN SCOTLAND

THE RAILWAY PHOTOGRAPHS OF R.J. (RON) BUCKLEY

COMPILED BY BRIAN J. DICKSON

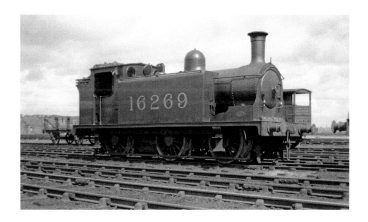

The
History
Press

First published 2015

The History Press
97 St George's Place,
Cheltenham, Gloucestershire, GL50 3QB
www.thehistorypress.co.uk

British Library Cataloguing in Publication Data.
A catalogue record for this book is available from the British Library.

ISBN 978 0 7509 6096 0

Typesetting and origination by The History Press
Printed by TJ Books Limited, Padstow, Cornwall

Cover: *Front*: It is approaching noon on Tuesday 4 May 1937 and the tranquil environs of Oban station are disturbed by the sudden explosion from the safety valves on both ex-CR Class 191 4-6-0 No. 14621 and ex-HR 4-6-0 No. 14586 *Urquhart Castle*. Both locomotives are well prepared for the 1 in 50 climb to the summit at Glencruitten at the head of the 12.05 p.m. departure to Glasgow Buchanan Street station. The 87 miles to Stirling will be a stiff test for both the locomotives and their crews; *Back*: During the 1950s, the secretary of the East Midland branch of the RCTS would arrange a weekend coach tour visiting Scottish locomotive depots. On the 1959 tour, Keith shed was reached during the afternoon of Saturday 16 May, and this evocative scene shows members of the club wandering among the locomotives stabled in the yard. Many enthusiasts will recall the sounds and smells encountered on such visits – all gone now, with the rare exception of a very few preserved railway sites.

Half-title: The driver of ex-HR 'Superheated Goods' class 4-6-0 No. 17954, stands patiently waiting for the photographer to complete his shot of the locomotive. Seen at Kyle of Lochalsh shed on Thursday 30 June 1938, she was delivered from R.&W. Hawthorn, Leslie & Co. during 1919 to be numbered 79 by the Highland. She would be the last of the class to be withdrawn by British Railways in October 1952.

Title: Bathed in bright summer sunshine, ex-CR Class 782 0-6-0 tank No. 16269 is sitting in the yard at Motherwell shed (Sunday, 21 July 1935). Built at St Rollox Works during 1898 she was one among over 140 examples of this class of locomotives. Numbered 56269 by British Railways, she would be withdrawn by them late in 1959, having given over sixty years of service.

INTRODUCTION

The railways in Scotland have especially fascinated enthusiasts for many years due to their distinct individuality. The operations of each of the five pre-grouping companies varied greatly. On the one hand there was the mighty North British Railway (NBR), with the huge amounts of coal traffic it carried out of Fife and the Lothians coalfields and its magnificent 'Atlantic' locomotives that were to be seen working over the Waverley Route to Carlisle and north to Aberdeen. At the opposite end of the operating spectrum was the tiny Great North of Scotland Railway (GNoSR), with its mostly rural services penetrating large areas of the north-east of Scotland and its picturesque Royal Deeside Line to Ballater. In comparison, the Highland Railway (HR) was distinguished by its long single-line branches serving the remote and isolated north and west of Scotland and the 'long drag' between Perth and Inverness. The grand Caledonian Raliway reigned supreme over the traffic flowing from the heavy industries in the central belt of Scotland, and it also operated fast express passenger trains north to Aberdeen and south to Carlisle, using beautifully equipped and liveried coaching stock. The compact and aptly described Glasgow and South Western Railway (G&SWR), operated in competition with the Caledonian on the busy passenger traffic to the Clyde coast towns and south-side suburban trains. It also faced stiff competition with the Caley in servicing the output of the Ayrshire coalfield.

Locomotive power again varied greatly from company to company, the HR leading the way with the introduction to Great Britain of the 4-6-0 wheel arrangement which it came to rely on for all its main-line work. The NBR relied on a succession of powerful 4-4-0 and 0-6-0 classes, whilst the GNoSR used nothing larger than a series of very graceful looking 4-4-0s, both companies never building or operating the 4-6-0 wheel arrangement. The North British did, however, build and operate three classes of the 'Atlantic' 4-4-2 wheel arrangement, something which no other Scottish company attempted. The Caledonian Railway (CR) similarly utilised many 0-6-0 and 4-4-0 classes, the most distinguished of which were the 'Dunalastair' series designed by J.F. McIntosh. They also built a number of superb 4-6-0 locomotives for their Anglo-Scottish expresses. The G&SWR unfortunately approached the grouping with a stud of locomotives that suffered from poor steaming qualities, primarily due to the influence of their last locomotive superintendent, R.H. Whitelegg. Previous locomotive superintendents, including Hugh Smellie, James Manson and Peter Drummond, had designed several classes of well-performing locomotives, but such was the final lamentable state of the South Western's locomotives that a mere handful lasted in operation with the London Midland and Scottish Railway (LM&SR) beyond 1939.

The railway grouping of 1923 brought Scotland the two rivals: the London and North Eastern Railway (LNER), which incorporated the NBR and the GNSR, and the LM&SR, the Scottish representatives being the Highland, the Caledonian and the G&SWR. By 1927 the versatile LM&SR 4-4-0 'Compounds' were to be seen working out of several ex-Caledonian sheds, and it was 1928 before the 2-6-0 'Crabs' were seen on the Highland main line to Inverness, with the Stanier-designed 'Black 5s' being introduced to the Highland lines in late 1934. From 1924 the LNER was transferring Class K2 2-6-0s to Eastfield shed in Glasgow and from here they found much work over many years on the West Highland Line. A shortage of suitable motive power within the former GNoSR territory also led the LNER to transfer a total of twenty-five examples of the ex-GER Class S69 (LNER Class B12) 4-6-0s from 1931 onward to be allocated to Aberdeen Kittybrewster and Keith sheds. They also introduced both the D11/2 class 4-4-0s – the so-called 'Scottish Directors' – from 1924 and the D49 three-cylinder 4-4-0 class 'Shires' from 1927, both to replace many of the ageing

NBR classes of 4-4-0s. During 1934 they started to replace the NBR 'Atlantics' with a similarly impressive class of locomotive, the Gresley P2, 2-8-2 monster, which was designed for the difficult Aberdeen road. By 1935, when Ron Buckley commenced travelling with the Birmingham Locomotive Club tours to Scotland, railway operations there were still being capably handled by many of those classes of pre-grouping locomotives inherited by the two new companies.

Ron Buckley's Scottish photographs show the changing locomotive scene throughout that country, illustrating from the latter part of the 1930s the ex-Highland 'Castle' and 'Clan' 4-6-0s and their 'Ben' 4-4-0s, and also the graceful looking ex-GNoSR 4-4-0s. Additionally there were the ex-NB 'Glen' and 'Scott' 4-4-0s, the Caledonian 4-6-0s, 4-4-0s and the numerous 0-6-0 classes remaining from both those companies. There were also a few rare examples of G&SWR locomotives still working. By the late 1940s all the ex-G&SWR locomotives had

gone and there were very few ex-Highland locomotives remaining in service, with the bulk of services in that territory being handled by the reliable 'Black 5s'. Similarly, very few GNoSR locomotives were still operational, but large numbers of ex-North British and Caledonian locomotives were still to be seen working throughout the Scottish region of British Railways.

Throughout this book the North British Locomotive Company is referred to as the NBL. It was in its heyday the largest locomotive construction company in Europe and was formed in 1903 by the amalgamation of three Glasgow locomotive construction companies: Neilson Reid & Co. of Hyde Park Works, Springburn; Sharp, Stewart & Co. of Atlas Works, Springburn; and Dübs & Co. of Queen's Park Works, Polmadie, whose work was distinguished by the distinctive diamond-shaped works' plates.

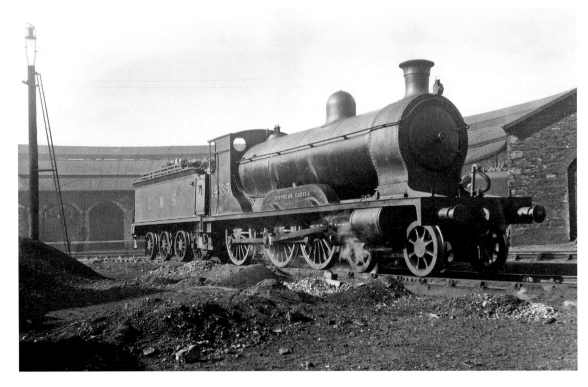

Sunday 15 September 1935 Parked at the entrance to the roundhouse at Inverness is ex-HR 'Castle' 4-6-0 No. 14685 *Dunvegan Castle*. Numbered 30 by the HR, she was the first of a pair of NBL-constructed members of the class delivered during 1910 and 1911. Designed primarily to handle the heavy passenger traffic between Perth and Inverness, she would be allocated at various times to both Inverness and Aviemore sheds. She was withdrawn in 1945.

Sunday 15 September 1935 Waiting to depart from Crieff station with a passenger train to Perth is ex-CR Class '766' 'Dunalastair II' 4-4-0 No. 14328. The fifteen examples of this highly successful design of locomotive by John McIntosh were constructed at St Rollox Works and introduced late in 1897, this particular example entering service early in 1898. She would be rebuilt in the form seen here during 1933 and would be withdrawn from service in 1940.

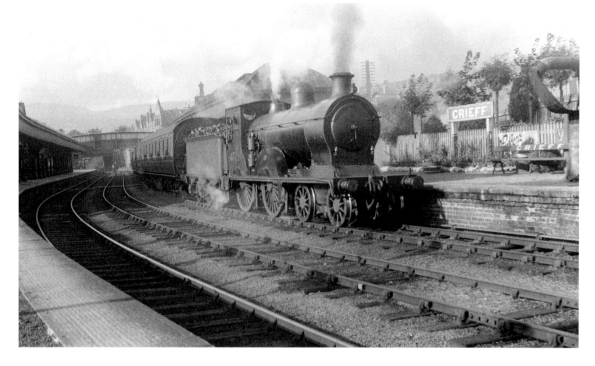

Sunday 15 September 1935 Parked beside the coal stack at Haymarket shed in Edinburgh is a rather grimy looking ex-NBR Class D (LNER Class J83) 0-6-0 tank No. 9831. Destined to become one of the Edinburgh Waverley station pilot locomotives in later LNER days, she had been constructed by Sharp, Stewart & Co. during 1901 and would become No. 68478 with British Railways before being withdrawn from service in 1958.

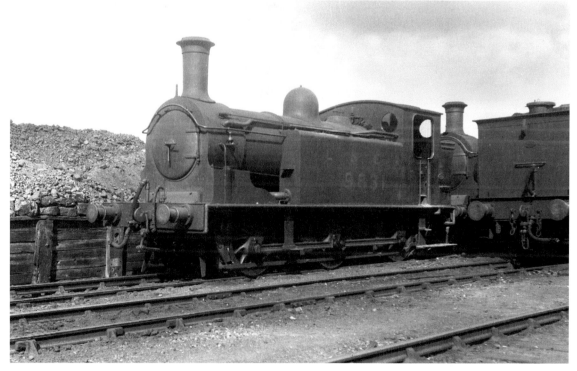

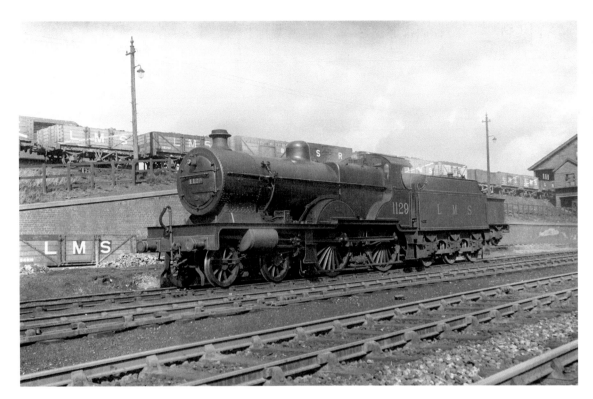

Friday 20 September 1935 Standing beside the ash-disposal pits at Balornock (later St Rollox) shed in Glasgow is LM&SR three-cylinder Compound 4-4-0 No. 1129. One of only twenty examples of the class, which were constructed at Horwich Works, she entered service in 1925 and would be allocated to both Balornock and Carlisle Kingmoor sheds during her lifetime. Becoming No. 41129 with British Railways, she would be withdrawn in 1955.

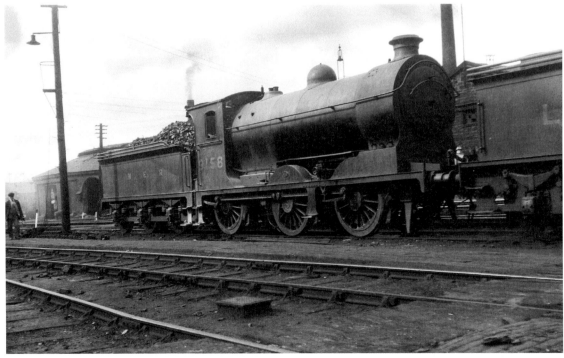

Friday 20 September 1935 The massive bulk of the ex-NBR Class B 0-6-0s is evident here, with No. 9158 parked in the yard at St Margarets shed in Edinburgh. Constructed by the NBL during 1918, she was an example of the un-superheated version of the class which would become classified J37 with the LNER. Later to become No. 4562 and ultimately No. 64562 with British Railways, she would be sent for scrap in 1963. In the background is a rare glimpse of the original NBR roundhouse constructed during the 1840s. The building became derelict during later LNER days and would finally be demolished, the turntable and tracks being retained and used to stable smaller tank locomotives and eventually diesel shunters.

Thursday 21 May 1936 Introduced to a design by William Stanier, the Class 5 mixed-traffic locomotives very quickly proved themselves to be efficient and reliable workhorses throughout the LM&SR system. Coming into traffic early in 1935, they were initially known by the railway fraternity as 'Black Staniers' but very quickly became known as 'Black 5s'. Their introduction to Scotland came as early as the summer of 1935 when examples were allocated to Perth for work on the Highland main line to Inverness. Seen here at Balornock shed is one of the few named examples, No. 5158 *Glasgow Yeomanry* bearing a 29C Dundee shedcode. A product of Armstrong Whitworth from July 1935 she would be withdrawn from service in 1964. Note that she is fitted with a vacuum pump, which would later be removed.

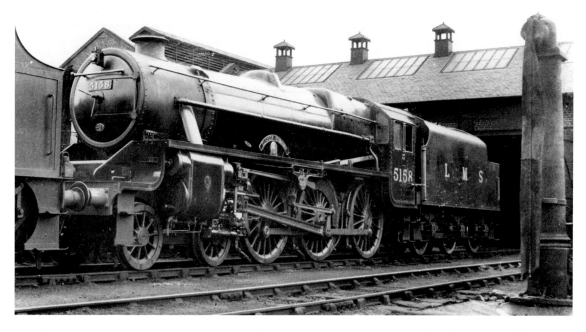

Saturday 23 May 1936 Parked in the yard at Carstairs shed is ex-G&SWR Class '33', later Class '51', 2-6-0 No. 17827, this wheelbase being something of a rarity for Scottish pre-grouping railways. She was one of only eleven examples of this superheated class constructed by the NBL in 1915, to a design by Peter Drummond, primarily to handle goods traffic. Initially all were based at the G&SWR shed in Carlisle to work the route to Glasgow. After the grouping, several examples were allocated to other sheds throughout the old G&SWR and CR territories. This locomotive would give twenty-three years of service before being withdrawn during 1938.

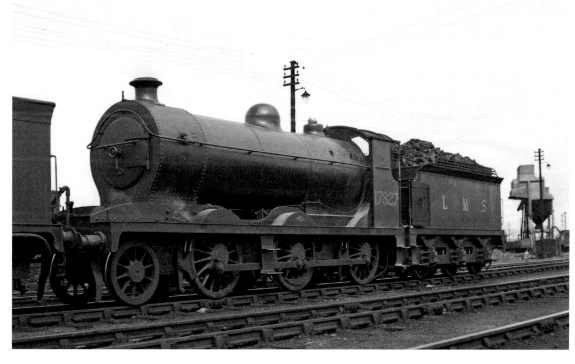

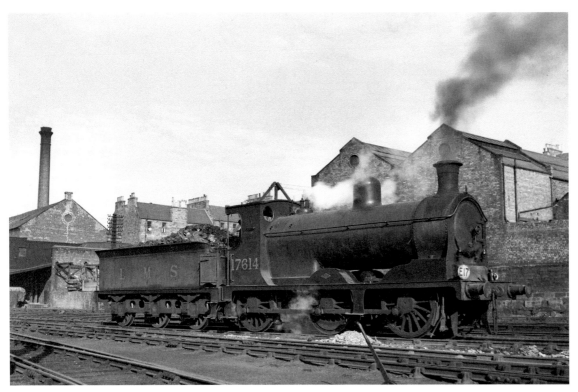

Saturday 23 May 1936 The primary LM&SR locomotive shed in the City of Edinburgh was that at Dalry Road. This ex-CR depot supplyied locomotive power for both the passenger services from Princes Street station and a number of goods yards, amongst them Lothian Road, Morrison Street and the ex-CR lines serving the busy ports of Leith and Granton. Seen here standing in the yard at Dalry Road is ex-CR Class '812' 0-6-0 No. 17614, one of only fifteen examples of this class, built by Dübs & Co. and entering service during 1890. She would become No. 57614 with British Railways and serve for over seventy years, being withdrawn in 1962.

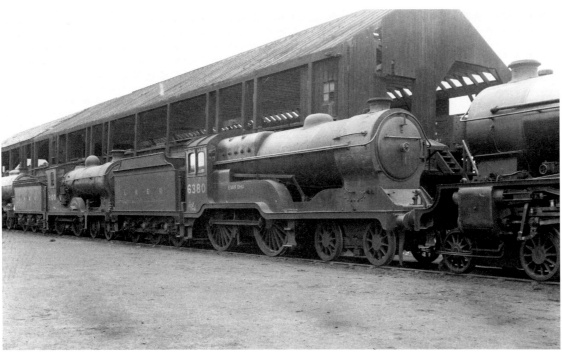

Sunday 24 May 1936 Constructed by the LNER to conform to the NBR loading gauge, the twenty-four examples of the former GCR Robinson-designed Class 11F 4-4-0s became known as the 'Scottish Directors'. Classified D11/2 by the LNER they all entered service during 1924 and soon acquired names from characters appearing in the novels of Sir Walter Scott. The locomotive seen here parked on the coal road at Eastfield shed in Glasgow is a Kitson & Co.-built example No. 6380 *Evan Dhu*. Allocated to Eastfield shed from new, she would spend the bulk of her working career based there, initially working services to Edinburgh, Perth and Dundee. She would be withdrawn from service by British Railways as No. 62673 during 1959. The character of Evan Dhu is a highlander who appears in the 1814-published Scott novel *Waverley*.

Sunday 24 May 1936 One of the most numerous of the Matthew Holmes-designed classes for the NBR was the Class 'C', 18in x 26in-cylindered 0-6-0 which commenced with the introduction of the first examples during 1888 and continued in batches until 1900 when a total of 168 were in service. The example seen here at Eastfield shed, No. 9647 *Albert*, was a Cowlairs Works-built example entering service during 1891. She would be rebuilt in the form seen here during 1913 and was one of the twenty-five members of the class requisitioned by the War Department during the First World War, spending roughly two years with the Railway Operating Division (ROD) in northern France. Classified J36 by the LNER, she would be withdrawn by them as No. 5223 during 1947. On their return from service, the NBR gave each of the twenty-five locomotives the name of a prominent person or place connected to the war in France. The town of Albert in northern France became a major centre during the Battle of the Somme in 1916.

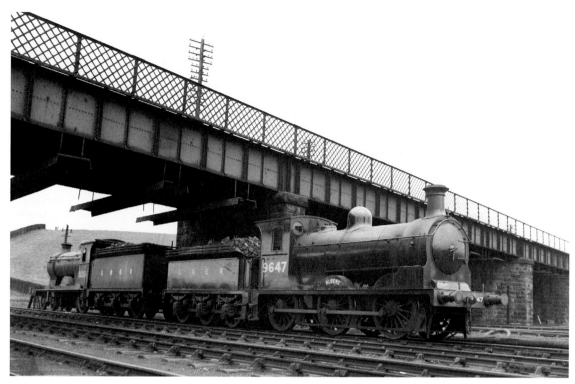

Monday 25 May 1936 Not the most handsome of locomotives, the Horwich Works 2-6-0s, which became known as 'Crabs' to railwaymen, were introduced during 1926, the design being attributed to the ex-Lancashire and Yorkshire Railway locomotive superintendent George Hughes. Primarily designed to handle goods traffic, ten examples of the class were allocated to the ex-HR territory during 1928 but were restricted to working the main line between Perth and Inverness via Slochd. Seen here at Stirling shed is No. 2800, a Crewe Works-built example from 1928. She would be withdrawn during 1965 numbered 42800 by British Railways.

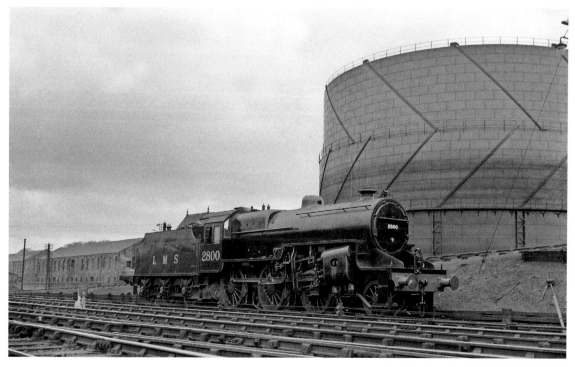

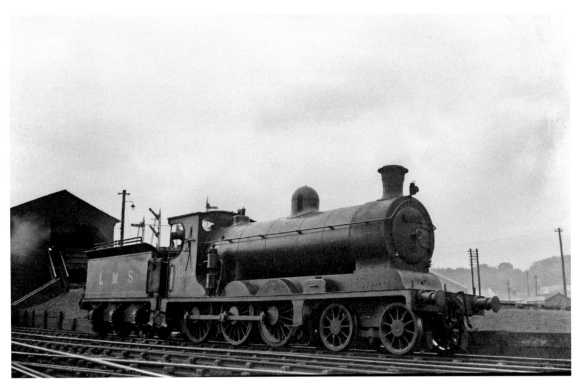

Monday 25 May 1936 With only nine months of its service remaining, ex-CR Class '55' 4-6-0 No. 14605 is waiting to be coaled at Stirling shed. Designed by John McIntosh specifically to operate on the Callander and Oban section of the CR, they were the first class of 4-6-0 locomotives to be introduced to the Caley in 1902, with a total of nine examples being constructed at St Rollox Works. Entering service during 1905, the locomotive seen here would be withdrawn in 1937.

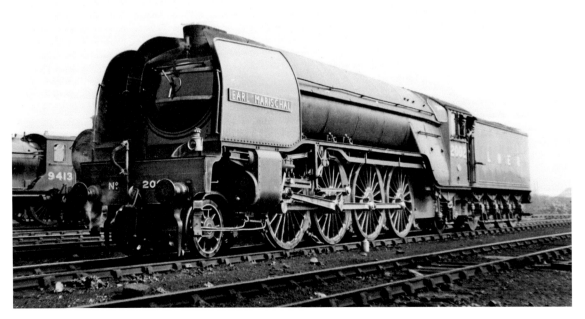

Tuesday 26 May 1936 With the withdrawal of the ex-NBR Atlantics occurring during the 1930s, the LNER answer for locomotives to work the difficult Edinburgh to Aberdeen route, with its heavy traffic, was the Nigel Gresley-designed Class P2 2-8-2. This immensely impressive class of locomotive consisted of only six examples, the first pair constructed at Doncaster Works during 1934, with the final four locomotives coming from the same works during 1936. The locomotive seen here standing at Ferryhill shed in Aberdeen is the second to be built, No. 2002 *Earl Marischal*. Five months later she would appear rebuilt with a streamlined front end, matching the four examples delivered earlier in 1936. These three-cylinder locomotives were all based at one of three Scottish sheds, Haymarket, Ferryhill or Dundee, and they were used almost exclusively on the passenger services between those cities. *Earl Marischal* would re-enter Doncaster Works and emerge rebuilt in June 1944 as a Pacific locomotive, designed by Edward Thompson. In this configuration, classified A2 and numbered 60502, she would be withdrawn from service in 1961.

Tuesday 26 May 1936 The reliance of the GNoSR in its use of the 4-4-0 wheel arrangement for its locomotives is well known; equally, the graceful lines of the designs by Cowan, Manson and Johnson are clearly evident in photographs of their locomotives. The William Pickersgill-designed ex-GNoSR Class T (LNER Class D41) 4-4-0s were all constructed by Neilson & Co. in Glasgow. Seen here at Kittybrewster shed in Aberdeen is No. 6819, later No. 62231 with British Railways. Entering service during 1896 she would give fifty-six years of service before being withdrawn in 1952. Note the use of a tender cab fitting on this locomotive, providing extra protection to the crew in bad weather.

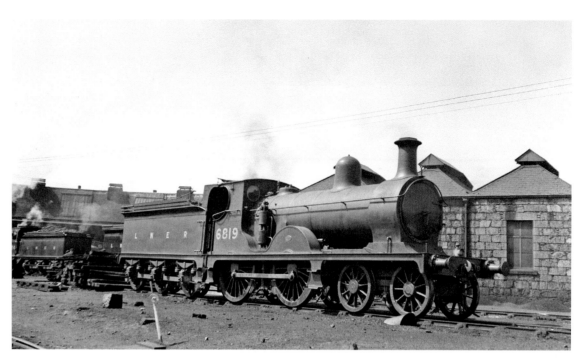

Tuesday 26 May 1936 At Kittybrewster shed, beautifully turned-out Class B12 (GER Class S69) 4-6-0 No. 8548 sits over one of the ashpits. Constructed by Wm. Beardmore & Co. of Glasgow during 1921, she would be fitted with the ACFI feed water equipment, as seen here in 1931. The LNER decided to transfer members of the class to the north-east of Scotland from 1931 onwards to supplement the ageing GNoSR 4-4-0 classes, with the example seen here moving north in 1933. She would be withdrawn from service in 1946.

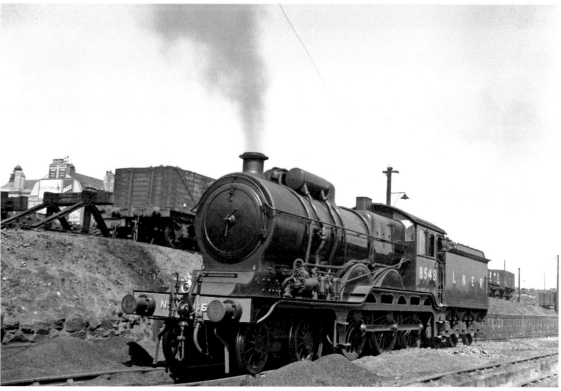

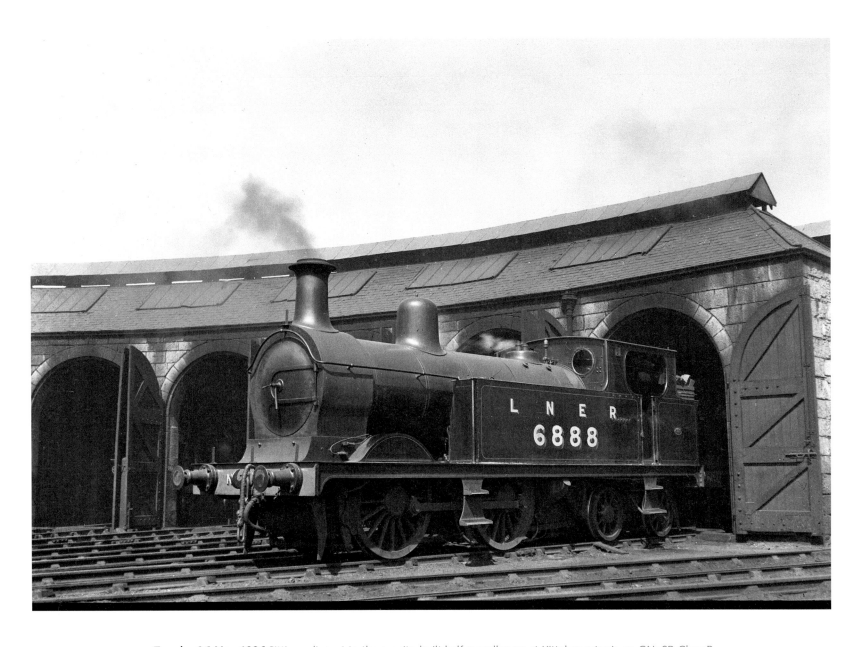

Tuesday 26 May 1936 Sitting adjacent to the granite-built half roundhouse at Kittybrewster is ex-GNoSR Class R (LNER Class G10) 0-4-4 tank No. 6888. Designed by James Johnson and constructed by Neilson & Co. in 1893, this class, comprising nine locomotives, was primarily used on the suburban workings around Aberdeen. Known as the 'Subbies' in local Aberdeen parlance, these trains served eight stations in the 6¼ miles between Joint station and Dyce, and eleven stations in the 16¾ miles to Banchory on the Deeside Line. The intensive services needed smart working by both the locomotives and the crews that worked them. Becoming redundant due to the expansion of the Aberdeen Corporation Tramways, six examples of the class were withdrawn during 1937, the locomotive shown here being one of that batch.

Tuesday 26 May 1936 Ex-NER Class E1 (LNER Class J72) 0-6-0 tank No. 2303 sits quietly between duties in Inverurie yard. Based on a design by Wilson Worsdell dating back to 1898, the last members of this class of 113 examples were built by Darlington Works for British Railways in 1951. The locomotive seen here was the first of a batch of ten locomotives constructed at Darlington Works during 1920. She would be allocated to the Aberdeen area in 1932. Numbered 68710 with British Railways, she would be withdrawn during 1959.

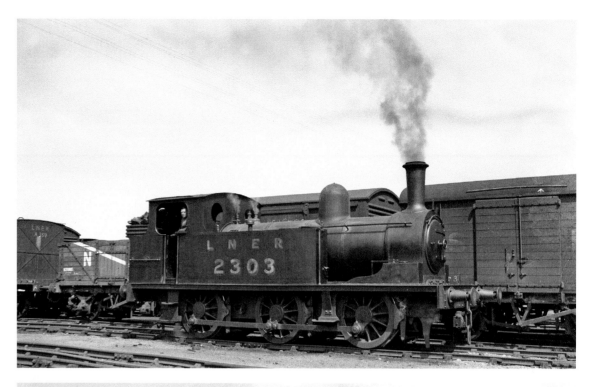

Tuesday 26 May 1936 Pausing at the head of a goods train in Inverurie station is ex-GNoSR Class V (LNER Class D40) 4-4-0 No. 6836. A member of another William Pickersgill-designed class, and one of the few locomotives constructed at Inverurie Works by the GNoSR, she entered service during 1910 and would survive to be numbered 62272 by British Railways and be withdrawn by them in 1955.

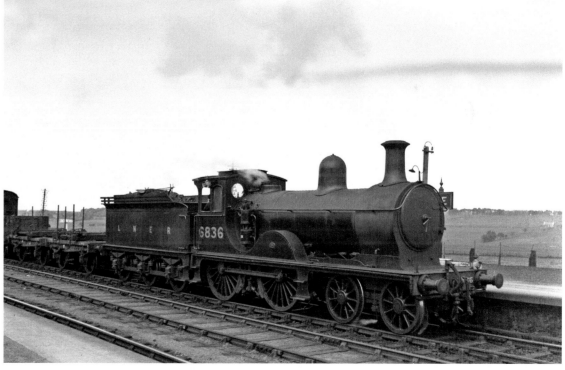

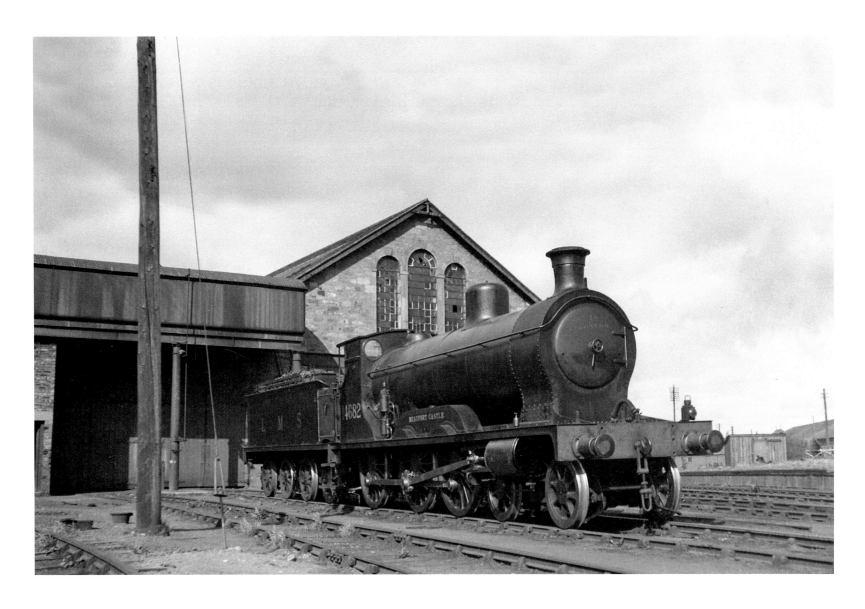

Wednesday 27 May 1936 Peter Drummond, the Locomotive Superintendent of the HR from 1896 until 1912, followed up on David Jones' pathfinding 4-6-0 design by introducing another powerful class of locomotive using the same wheel arrangement during 1900. This was the 'Castle' class, of which six examples entered service in mid 1900, with four further locomotives arriving in mid 1902, all from Dübs & Co. in Glasgow. Two further examples followed in 1910–11 and four more during 1913, all from the NBL. These first sixteen locomotives used 5ft 9in driving wheels, but the final three class members, delivered in 1917 during the tenure of Christopher Cumming as locomotive superintendent, utilised larger 6ft driving wheels. All were classified 3P by the LM&SR. These well-proportioned locomotives were designed primarily to work the heavy traffic on the Inverness to Perth route, although they migrated to work on the Kyle and Far North Line after the introduction of the later 'Clan' and 'Clan Goods' classes of 4-6-0s. During LM&SR days they were also to be found working on the ex-CR Callander and Oban Line. Here, LM&SR No. 14682 *Beaufort Castle* is seen sitting outside Lochgorm Works in Inverness. Originally numbered 147 by the HR, she was from the batch delivered by Dübs & Co. in 1902 and would be withdrawn from service during 1943. Note the flat-top dome fitted to this example.

Wednesday 27 May 1936 A group of loco men wait patiently whilst the photographer captures this image of LM&SR No. 14676 *Ballindaloch Castle* as it stands on the turntable at Inverness shed. Originally numbered 141 by the HR, she was the second member of the class to be delivered in 1900 from Dübs & Co. and was destined to be withdrawn in 1937. Note the large brackets on the front bufferbeam, ready to take the fitting of a snowplough when required.

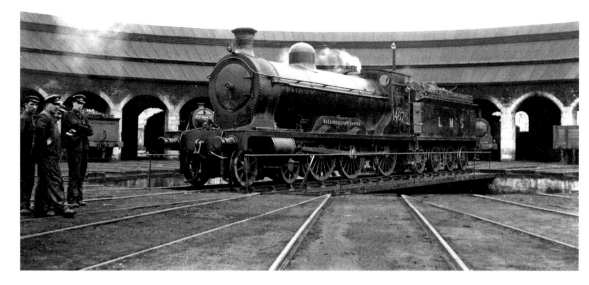

Wednesday 27 May 1936 LM&SR No. 14690 *Dalcross Castle* is seen here in the yard at Inverness. Delivered by the NBL during 1913 and numbered 29 by the HR, she would be withdrawn from service in 1947.

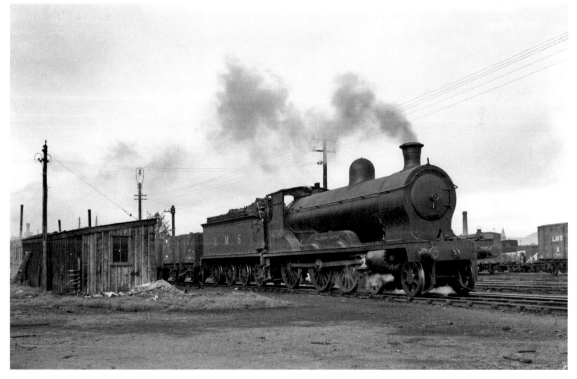

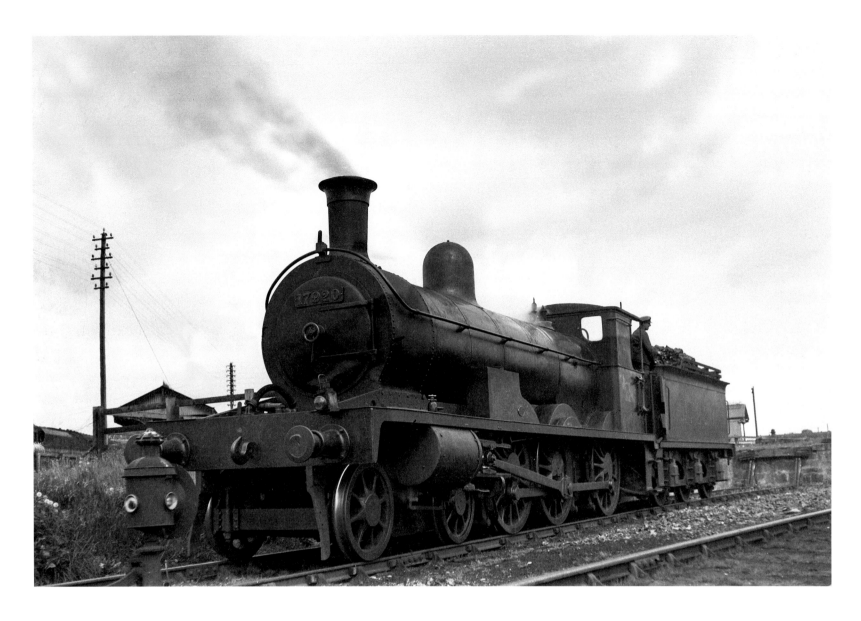

Wednesday 27 May 1936 The first class of locomotive in Britain to be designed and constructed using a 4-6-0 wheel arrangement were the fifteen examples of David Jones 'Big Goods'. In later years referred to as 'Jones Goods', they were in all respects larger than anything previously seen on HR metals. Constructed by Sharp, Stewart & Co. in Glasgow, the first of the class, No. 103, entered service during September 1894 and was quickly followed by the remainder of the class. With a higher boiler pressure and larger cylinders than any previous HR design, they were also curiously fitted with flangeless centre driving wheels, which were later altered to the flanged type. These powerful locomotives were at home handling both goods and passenger traffic, primarily over the difficult Inverness to Perth route, and were eventually utilised over the whole HR system. The introduction of Stanier 'Black 5s' into Scotland during 1935 led to the gradual withdrawal of the 'Jones Goods' class, with the last example coming out of service during 1940. Fortunately the LM&SR had set aside No. 103 for preservation; she now resides at the Glasgow Museum of Transport. The locomotive seen here at Forres shed is No. 17920, formerly HR No. 107. One of only seven members of the class still working at this time, she would be withdrawn in 1937.

Wednesday 27 May 1936 Designed by Peter Drummond and introduced in 1900, the twelve examples of Class '18' were of the only class of 0-6-0 tender locomotives used by the HR. The class was constructed in three batches: six during 1900 from Dübs & Co., four during 1902, again from Dübs & Co., and finally two examples delivered during 1907 from the NBL. The first six locomotives were originally paired with large double-bogie tenders, which were later exchanged for the six-wheeled variety from the 'Small Ben' class. Unusually, the second batch of four locomotives was initially fitted with water-tube fireboxes, which over the following years were exchanged for conventional fireboxes. Intended primarily for goods traffic on the lines north of Inverness, they were equally at home on passenger duties, and at some time during their existence the class acquired the nickname 'Barneys'. Such was their usefulness that eleven of the class would survive into the late 1940s, with six actually being taken into British Railways' stock, the last example being withdrawn during December 1951. *Top right*: Seen here in the yard at Inverness shed is ex-HR 'Barney' 0-6-0 No. 17694. Entering service during 1900 numbered 135 by the HR she would be withdrawn by British Railways in 1950. *Bottom right*: On the same day as the previous photograph, having paused whilst making up a goods train in Inverness yard, ex-HR 'Barney' 0-6-0 No. 17693 is looking in good external condition. The first of the class to be delivered to the HR during 1900, she would be numbered 134 by them and see service until withdrawal in 1949. Note that she retains both the Dübs & Co. diamond-shaped works' plate on the middle splasher and the LM&SR equivalent on the front splasher.

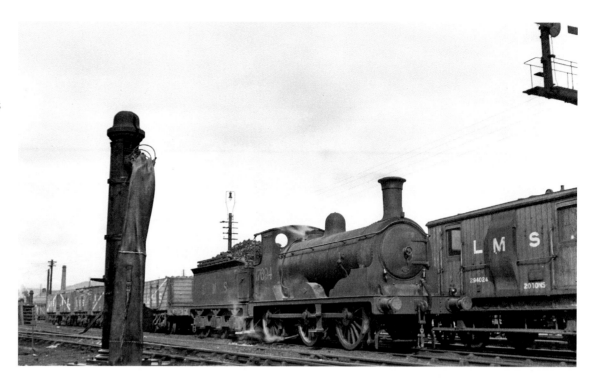

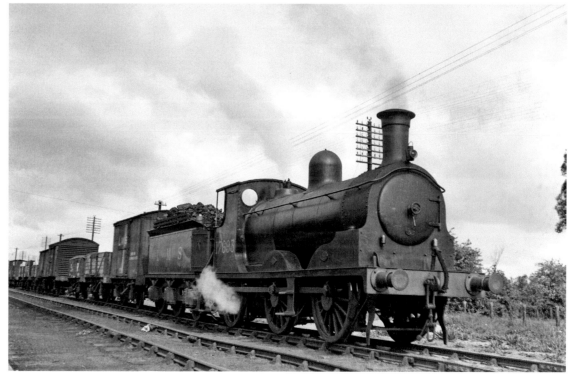

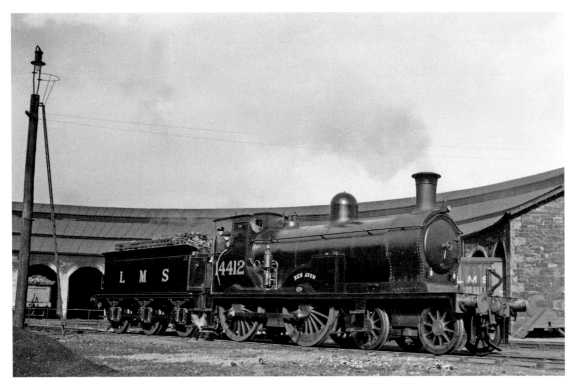

Wednesday 27 May 1936 The crew on the footplate of ex-HR 'Small Ben' 4-4-0 No. 14412 *Ben Avon* peer inquisitively at the photographer before departing from Inverness shed for their next duty. Designed by Peter Drummond, the Class '1', or 'Small Bens' as they became known, were constructed in three batches, the first eight examples from Dübs & Co. during 1898–99 and the next nine locomotives at the HR's own works at Lochgorm from 1899–1901. The final three locomotives were delivered from the NBL in 1906. All were named after mountains within the HR sphere of influence. Designed initially to work between Inverness and Wick and the Aberdeen trains, they would eventually migrate to work over most of the HR territory. *Ben Avon*, seen here, was one of the rare examples of a Lochgorm Works-constructed locomotive entering service in 1901. She would be allocated to Inverness shed for most of her working life and be withdrawn during 1947.

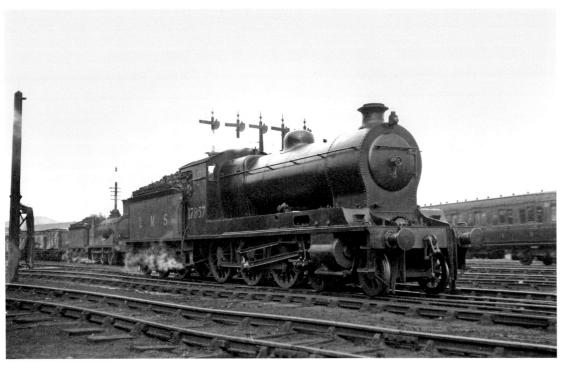

Wednesday 27 May 1936 Ex-HR 'Superheated Goods' 4-6-0 No. 17957 is seen here at Inverness. Following the success of both David Jones' and Peter Drummond's 4-6-0 types, Christopher Cumming, the locomotive superintendent of the HR from 1915 until 1922, continued with the supply of locomotives using this wheel arrangement. In conjunction with R.&W. Hawthorn Leslie & Co. of Newcastle, a design was prepared for a powerful class of goods locomotive, known initially as 'Superheated Goods', and later 'Clan Goods'. Constructed in two batches of four examples, each delivered during 1918 and 1919, these locomotives utilised 5ft 3in driving wheels, Belpaire fireboxes and Robinson superheaters, and were classified 4F by the LM&SR. Six examples of the 'Clan Goods' survived to serve with British Railways. The example here was the last of the class to be delivered in 1919; she would be withdrawn during 1946.

Wednesday 27 May 1936 The impressive-looking William Pickersgill-designed Class '60' 4-6-0s for the CR first appeared from St Rollox Works during 1916, with six examples initially being constructed. Seen here at Perth South shed is No. 14654. Entering service in March 1917, she would become No. 54654 with British Railways and be withdrawn in January 1952. Primarily designed for express passenger workings, during LM&SR days this class of locomotive also migrated to working goods trains. So useful were they that the LM&SR actually built a further twenty examples during 1925 and 1926, many of which survived to reach British Railways' ownership and be withdrawn in the early 1950s.

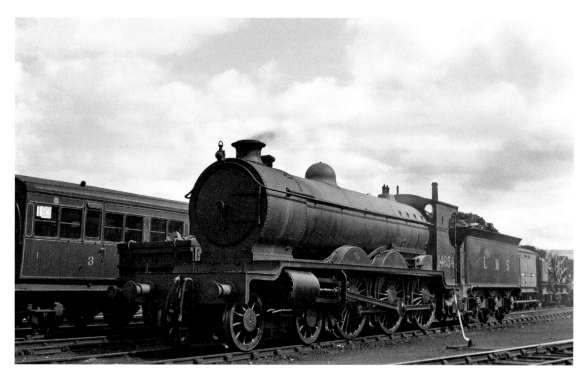

Wednesday 27 May 1936 Another impressive locomotive is seen here at Stirling station at the head of a southbound goods train. Un-rebuilt LM&SR 'Royal Scot' Class 4-6-0 No. 6155 *The Lancer* was one of the twenty examples of the class constructed at Derby Works in 1930. Designed during the tenure of Henry Fowler, the three-cylinder 'Royal Scots' were an immediate success, with the first batch of fifty locomotives being built and delivered in record time during 1927 by the NBL in Glasgow. The whole class was rebuilt with tapered boilers between 1943 and 1955, with the locomotive seen here undergoing its rebuild in 1950. She would be numbered 46155 by British Railways and be withdrawn in 1964.

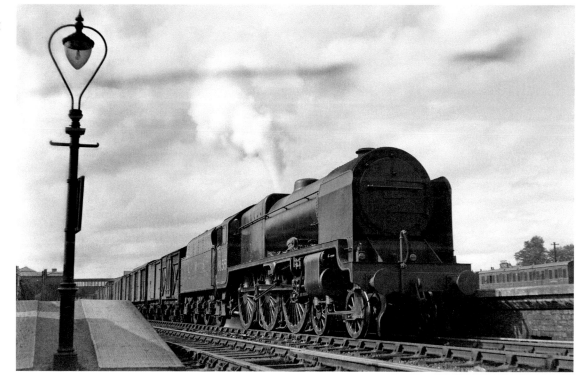

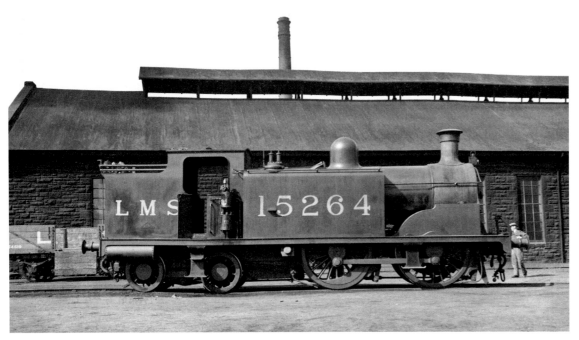

Thursday 28 May 1936 The CR 'Standard Passenger' 0-4-4 tank locomotives originated with a design by John McIntosh and entered service during 1895. Initially ten locomotives of Class '19' were constructed at St Rollox Works, with further batches, latterly of Class '439' and bearing slight modifications, appearing from 1897 until 1922, by which time a total of 114 examples were in service. The LM&SR thought the class useful enough to order a further ten locomotives from Naysmyth Wilson in Manchester, which were delivered during 1925. The example seen here at Ayr shed is one of those later locomotives, No. 15264, bearing the distinctive triangular builders' plate on the bunker side. Allocated to both Ayr and Hurlford sheds for most of her working life, she was, however, based at St Albans shed in England for a short time during 1927. Numbered 55264 by British Railways, she would be withdrawn in 1961.

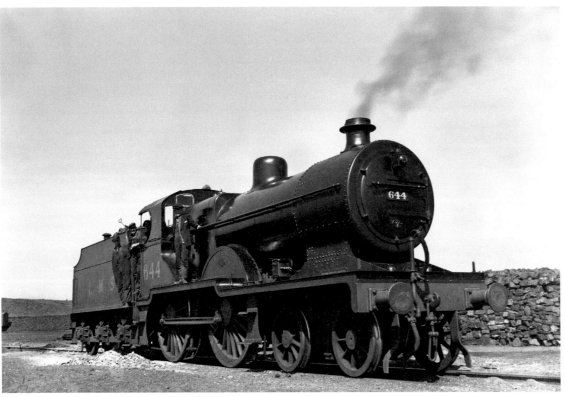

Thursday 28 May 1936 The cleaners at Ardrossan shed have almost completed their work on LM&SR Class 2P 4-4-0 No. 644 and are happy to be photographed showing off the results of their labour. An example of a batch of twenty locomotives constructed at Crewe Works during 1931, she would be based at Hurlford shed for most of her working life and be withdrawn numbered 40644 in 1959.

Thursday 28 May 1936 The two photographs here show two forms of the famous 'Dunalastair' series of express passenger 4-4-0 locomotives, which was designed by John McIntosh for the CR and introduced in 1896. Above is seen Class '766', 'Dunalastair II' No. 14331, formerly No. 775 with the CR, which entered service from St Rollox Works during 1898. Rebuilt in the form seen here during 1934 she would be withdrawn in 1945. Below is the later Class '900', 'Dunalastair III' No. 14344, formerly No. 895 with the Caley. Coming out of St Rollox Works in 1900, she would be withdrawn from service during 1941. Both locomotives are seen here parked at Ardrossan shed. Note the differences of detail: chimney and dome heights and shapes, and the length of the smokeboxes. Both are also carrying the CR style of route indicator semaphore on the front running board.

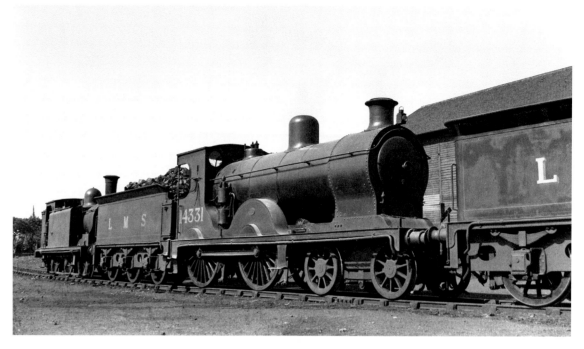

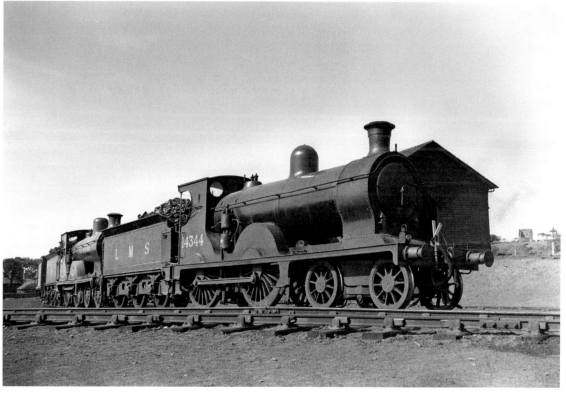

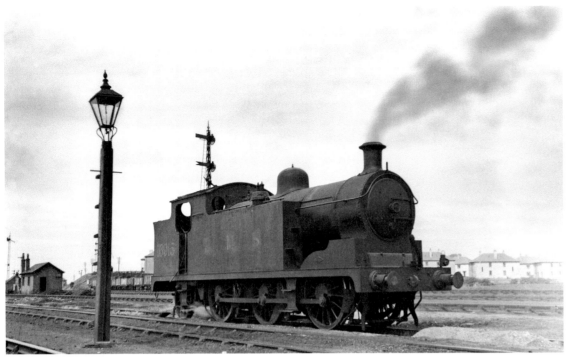

Thursday 28 May 1936 In January 1912, Peter Drummond became locomotive superintendent with the G&SWR after the retirement of James Manson at Kilmarnock. Drummond had a brilliant career with the HR, and in his short tenure with the G&SWR (he died in 1918) he again introduced several classes of successful locomotives, including the twenty-eight examples of the powerful Class '1' 0-6-2 tanks. All were constructed by the NBL and delivered in three batches: six during 1915–16, twelve during 1917 and a final ten in 1919. Classified 3F by the LM&SR, many members of the class were transferred to sheds in England after the grouping. Seen here standing over the ashpit at Hurlford shed and looking in a rather grimy condition is No. 16915, one of the 1917-built batch of locomotives. She would be withdrawn in 1938.

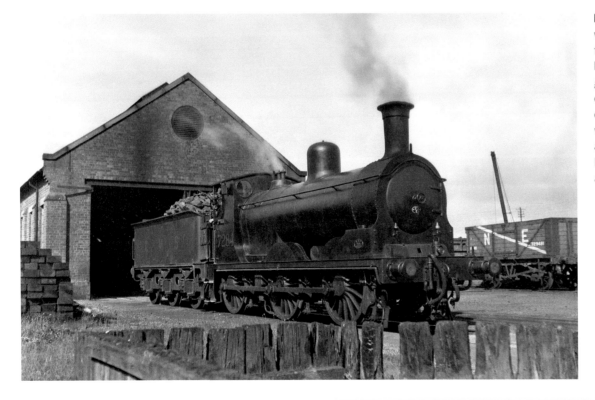

Friday 29 May 1936 Dugald Drummond was locomotive superintendent of the CR from 1882 until 1890, and his first design of locomotive for that company was a 0-6-0 goods locomotive, Class '294', introduced during 1883. Seen here is a good, clean example at Newton Stewart shed. No. 17284 was constructed at St Rollox Works in 1886 and survived to become No. 57284 with British Railways, before being withdrawn after seventy-six years of service in 1962.

Thursday 28 and Friday 29 May 1936 Prior to the arrival of Peter Drummond at the G&SWR, James Manson was the locomotive superintendent for twenty-two years, during which time he introduced several classes of 0-6-0 goods tender locomotives, all of which gained favourable reputations. It was in later years, after reboilering took place, that steaming problems occurred and their reputation suffered. Seen here (*above*) on 29 May is ex-G&SWR Class '361', later Class '101', No. 17504, standing in Dumfries goods yard prior to working a train. A product of the NBL during 1907, she is seen in her rebuilt form with a Robert Whitelegg-designed boiler. She would be withdrawn from service six months later during November 1936. The final Manson design of 0-6-0 goods tender locomotive, the Class '17', later Class '86', was introduced in 1910, with all fifteen examples being constructed by the NBL. Seen here (*below*) at Hurlford shed on 28 May is No. 17519, looking in good external condition. This class had rather pleasing, well-proportioned lines and, apart from one example, did not suffer from being reboiled with inferior boilers during their lifetime. The locomotive would be withdrawn four months after this picture was taken.

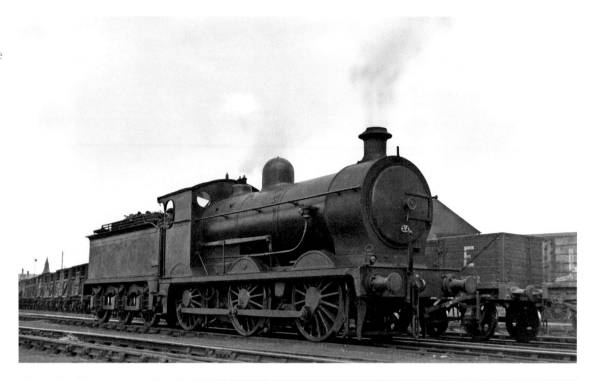

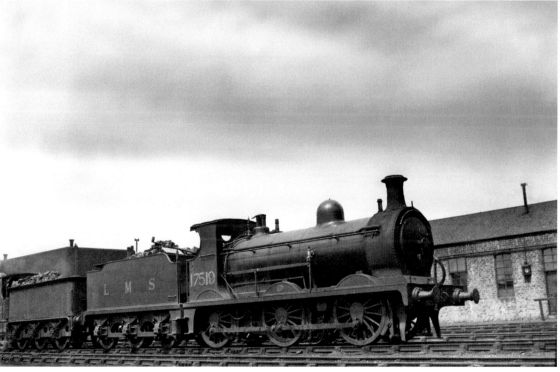

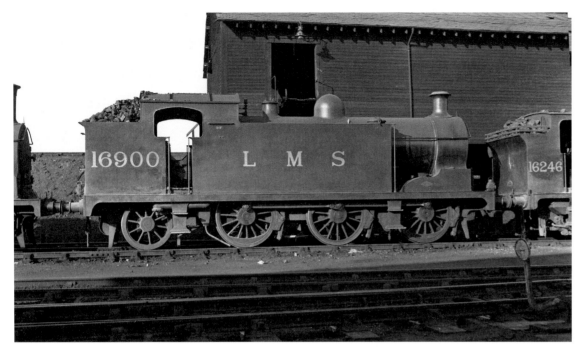

Sunday 2 May 1937 Parked beside the coaling stage at Hurlford shed is ex-G&SWR Class '1' 0-6-2 tank No. 16900, the first of a batch built by the NBL during 1919. With slightly larger-capacity water tanks than the earlier built examples, this powerful-looking locomotive still carries the distinctive diamond-shaped NBL builders' plate on the front splasher and has the LM&SR classification '3F' painted on the cab side. She would only give twenty years of service before being withdrawn during 1939.

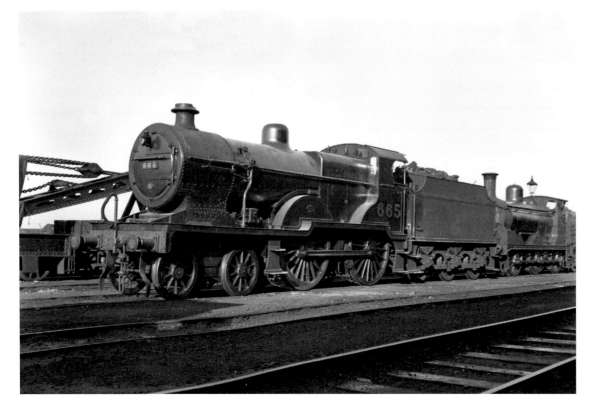

Sunday 2 May 1937 Also parked in the yard at Hurlford shed is LM&SR Class 2P 4-4-0 No. 665. A long-term resident at this shed, she was constructed at Derby Works in 1931 and would be withdrawn numbered 40665 during 1962.

Sunday 2 May 1937 Another ex-CR veteran is seen here at Ardrossan shed. Class '294' 0-6-0 No. 17282 came into service in 1886 and would survive sixty-nine years to be withdrawn by British Railways as No. 57282 during 1955. In a similar way to the ex-NBR Class C 0-6-0s, twenty-five members of this class were requisitioned by the War Department during the First World War and served from 1917 until 1919 with the ROD in France, all returning safely.

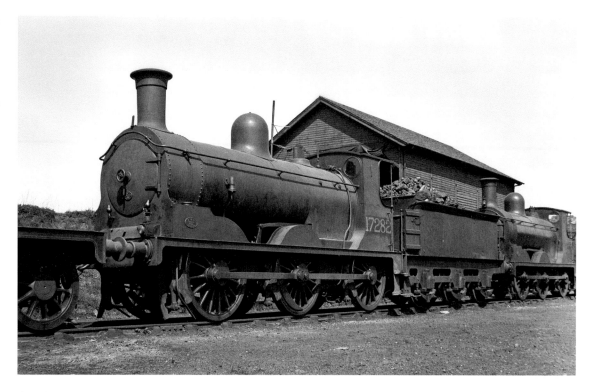

Sunday 2 May 1937 Seen here at Parkhead shed in Glasgow is LNER Class J36 0-6-0 No. 9744, formerly NBR Class C No. 744. She was a product of Cowlairs Works, entering service during 1898. Rebuilt in the form seen here during 1919, she was one of the earlier withdrawals of the class going for scrap in 1947.

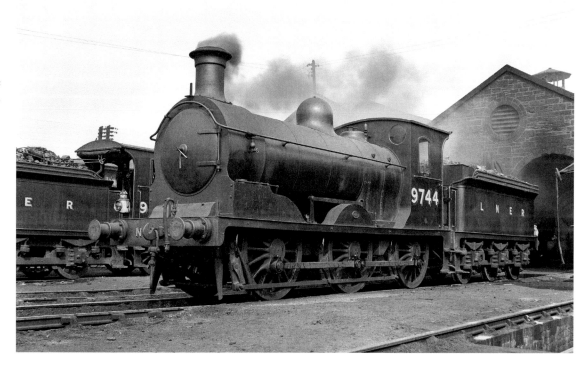

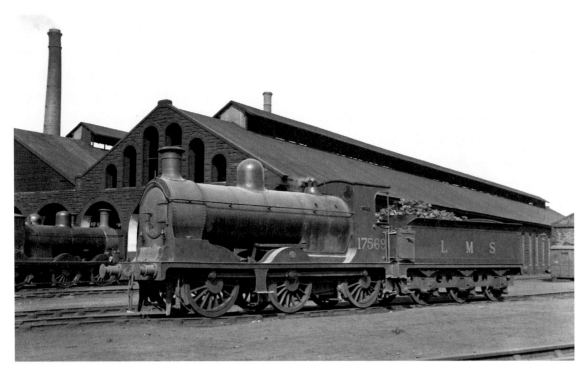

Monday 3 May 1937 Designed by John McIntosh and introduced during 1899, the CR Class '812' 0-6-0 locomotives were a powerful and versatile addition to their stock. Examples were constructed incorporating the Westinghouse brake or the vacuum brake, and many class members were fitted with a steam brake only. This enabled their working on a wide variety of coaches and goods vehicles, including those from other railway companies. Seen here at Ayr shed is No. 17569, a product of Neilson Reid & Co. in 1899. She would reach British Railways ownership and be numbered 57569, to be withdrawn after sixty-three years of service in 1962. Note the impressive shed building in the background. Built by the G&SWR and dating from the late 1870s, it would survive almost intact until the 1970s.

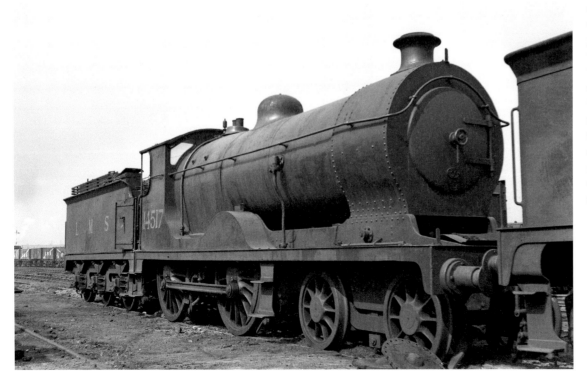

Monday 3 May 1937 The final class of 4-4-0 locomotives supplied for express passenger work on the G&SWR was the superheated Class '137', later Class '325', designed by Peter Drummond and constructed at the company works at Kilmarnock. All six examples entered service during 1915. Seen here is No. 14517 sitting in St Rollox Works yard with her cylinder-head covers removed. She was probably condemned at this time, as her official withdrawal date is shown as the same month.

Monday 3 May 1937 In sparkling condition at Balornock shed is LM&SR Class 5XP 4-6-0 'Jubilee' No. 5727 *Inflexible*. Only seven months old, having exited Crewe Works during October 1936, she was one of the last examples of the class to enter service. Initially the class was disappointing in its performance due to erratic steaming, but the change to larger superheaters improved it dramatically. This locomotive would be numbered 45727 with British Railways and be withdrawn from service during 1962.

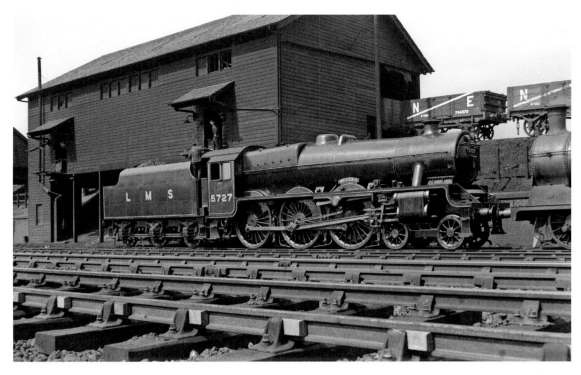

Monday 3 May 1937 Sitting next to the 'Jubilee' in the previous photograph is ex-CR Class '812' 0-6-0 No. 17624, formerly No. 289 with the Caledonian. A product of the neighbouring St Rollox Works and coming into service during 1899, she would be withdrawn fifty years later in 1949.

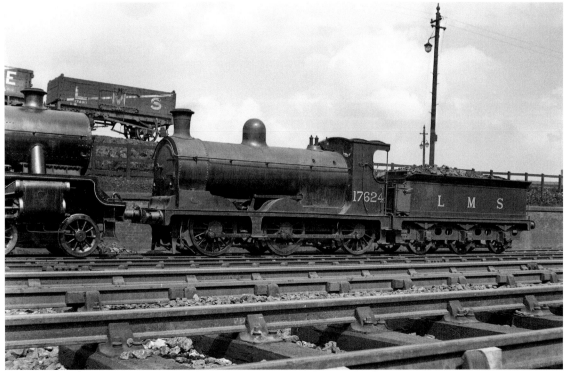

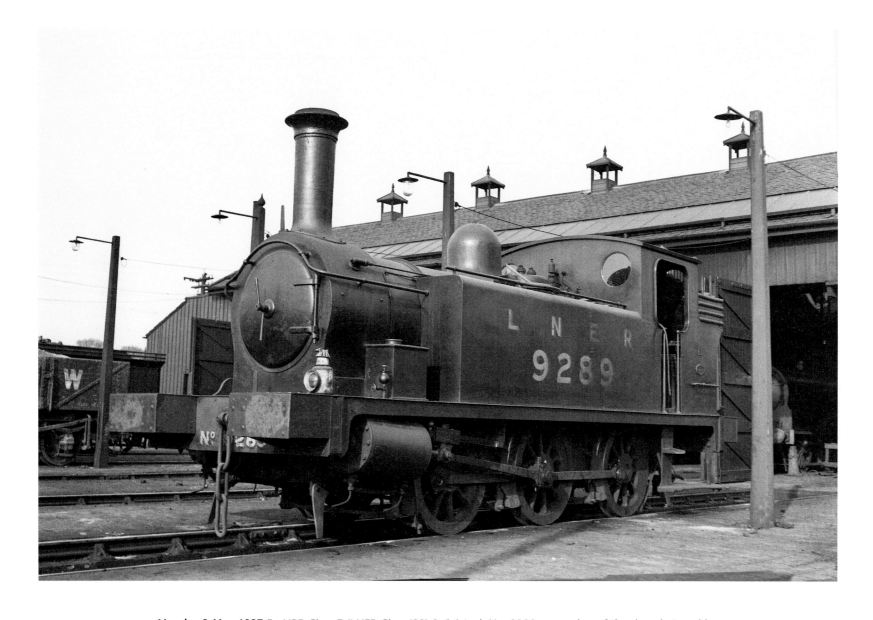

Monday 3 May 1937 Ex-NBR Class F (LNER Class J88) 0-6-0 tank No. 9289, a member of the class designed by William Reid as that railway's standard light-shunting locomotive. A total of thirty-five examples, all originating from Cowlairs Works in batches between 1904 and 1919, would survive to reach British Railways' ownership. Primarily employed in harbours and docks around the old NBR system, the locomotive seen here was one of the last to be constructed, during 1919, and would be withdrawn in 1960 numbered 68354.

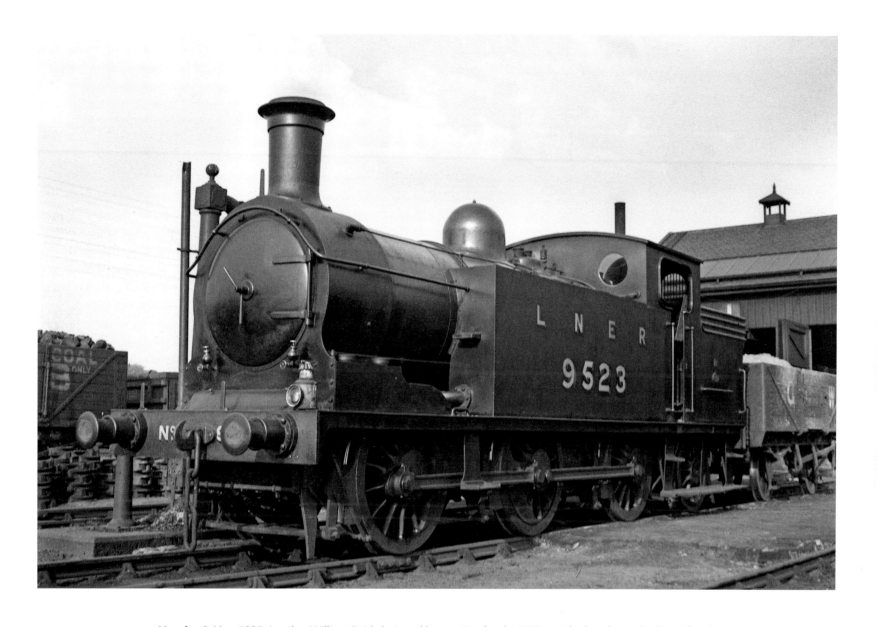

Monday 3 May 1937 Another William Reid-designed locomotive for the NBR was the handsome-looking Class A 0-6-2 tank. Later classified N15 by the LNER, these locomotives were designed to handle goods traffic and could be found all over the NBR system, with many undertaking shunting duties in large yards. The locomotive here, No. 9523, is equipped with a shunter's footboard and handrail for just such duties. She was constructed by Robert Stephenson & Co. during 1923 and would become No. 69200 with British Railways before being withdrawn during 1958.

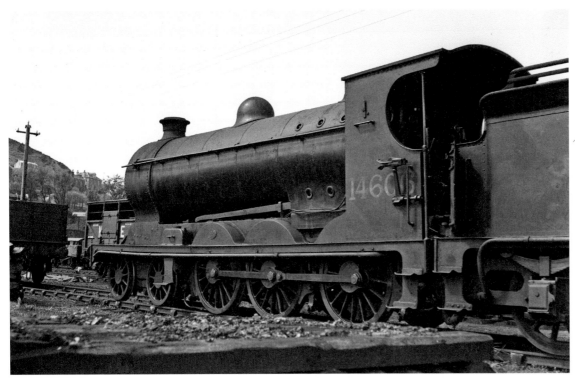

Tuesday 4 May 1937 Parked in the yard at Oban shed is ex-CR Class '55' 4-6-0 LM&SR No. 14606. Built at St Rollox Works and entering service in 1905, she would be numbered 52 by them. She was designed by John McIntosh specifically to work the Callander and Oban section of the Caley, and is seen here in her rebuilt form with a larger boiler. Destined to be the last of the class of nine locomotives to be withdrawn, she would go for scrapping six months later during November 1937. The unusual photographic angle allows the detail of the Manson tablet exchange mechanism to be clearly seen.

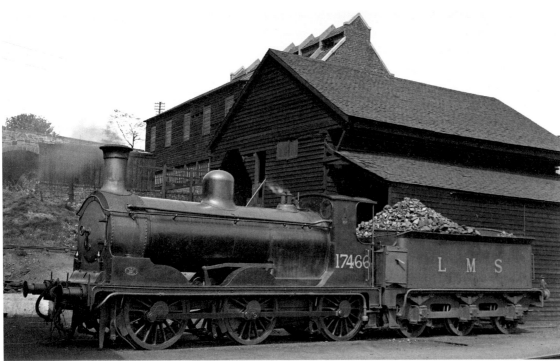

Tuesday 4 May 1937 John McIntosh continued the building of the smaller mixed-traffic class of 0-6-0s for the Caledonian with only minor modifications. From 1895 until 1897, over eighty examples of the Class '709' appeared, all from St Rollox Works. Standing beside the coaling plant at Oban shed is No. 17466, her tender loaded very high with coal. Entering service during 1897, she would be withdrawn in 1949.

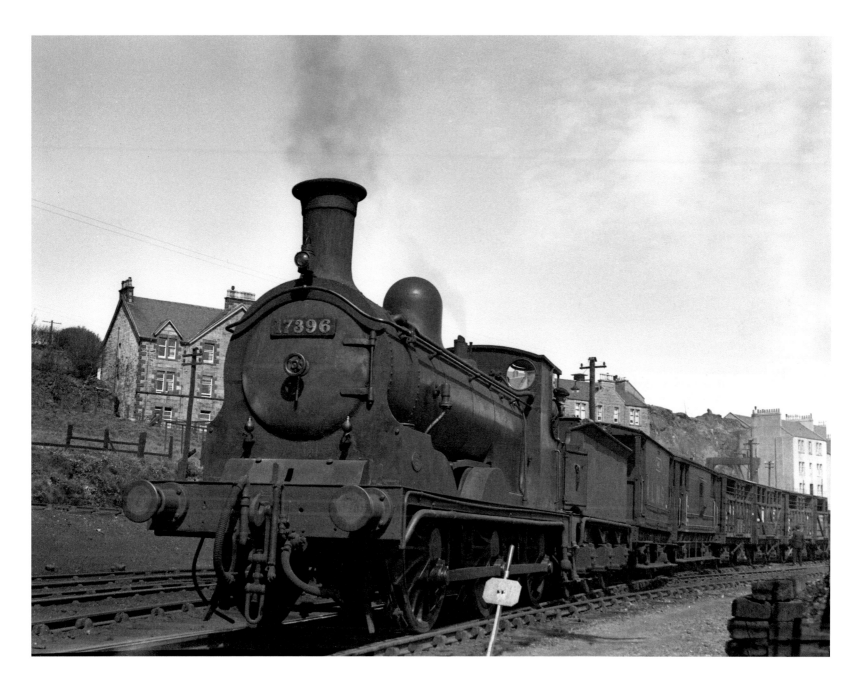

Tuesday 4 May 1937 This splendid photograph shows an earlier-built example of the Class '709'. No. 17396 is making up a train of cattle wagons in the yard at Oban. Constructed in 1895, she would become No. 57396 with British Railways and be withdrawn after sixty-three years of service during 1958.

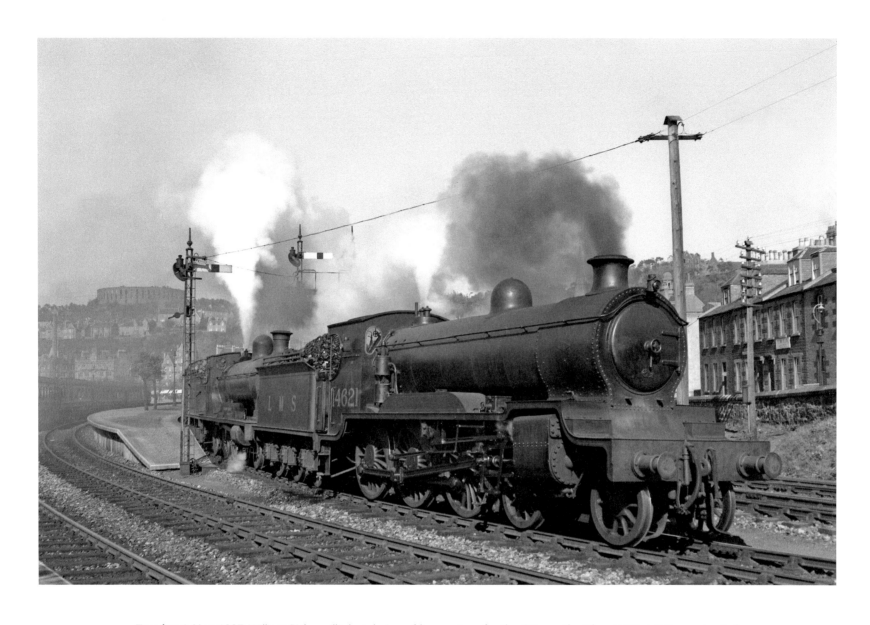

Tuesday 4 May 1937 William Pickersgill's last design of locomotives for the CR was the Class '191' 4-6-0, constructed specifically for the Oban route with its axle weight restriction. Eight examples were built by the NBL and all delivered during December 1922, numbered 191–198 by the Caledonian and becoming 14619–14626 with the LM&SR. No example survived to reach British Railways ownership. Seen here is No. 14621 as pilot to ex-HR No. 14686 *Urquhart Castle*, waiting to depart from Oban station with a train for Glasgow. The class was constructed with un-superheated boilers and, unusually, Walschaerts gear, utilising slide valves instead of piston valves. They were classified 3P by the LM&SR and the locomotive seen here became the last of the class to be withdrawn during 1945.

Tuesday 4 May 1937 Designed by John Lambie for the CR, the twelve members of Class '1' 4-4-0 tanks were originally fitted with condensing gear specifically to work the Glasgow Low Level lines. In later years they migrated to become station pilots at a number of larger stations. All were constructed at St Rollox Works during 1893. The example seen here acting as Oban station pilot is No. 15025, formerly No. 6 with the Caley. She would survive for a further year before becoming the last of the class to be withdrawn during 1938.

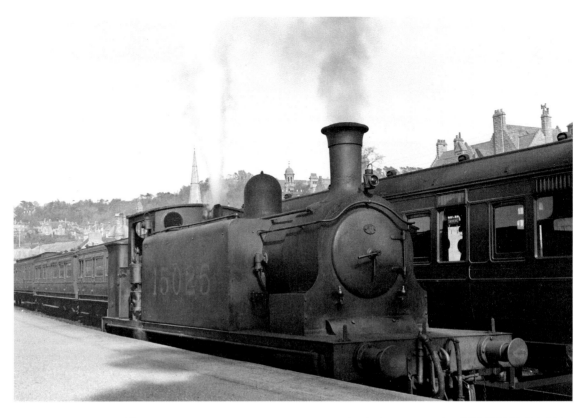

Wednesday 5 May 1937 This handsome-looking tank locomotive parked in the yard at Thornton shed is ex-NBR Class M (LNER Class C15) 4-4-2 tank No. 9015. Designed by William Reid and constructed by the Yorkshire Engine Co., a total of thirty examples were delivered between 1911 and 1913. Allocated primarily to the sheds in Edinburgh and Glasgow to work the suburban traffic around those cities, in later years a number were based at Dundee Tay Bridge shed, with the locomotive seen here being allocated to Dunfermline. She came into service during 1913 and would be withdrawn by British Railways in 1956 numbered 67466.

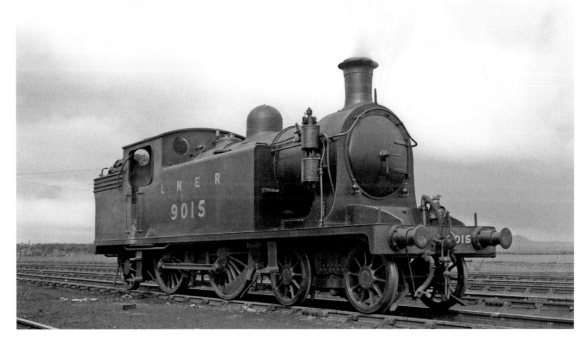

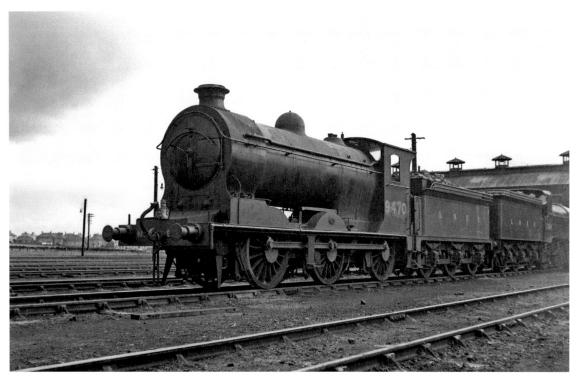

Wednesday 5 May 1937 Thornton Junction and shed lay at the heart of the coal industry in Fife, and in consequence a large number of goods locomotives were allocated there. Ex-NBR Class S (LNER Class J37) 0-6-0 No. 9470 is seen here sitting on one of the shed roads. She was the first of a batch of this superheated-boiler version of the locomotive to be delivered from the NBL in November 1919. Designed by William Reid to handle the heavy mineral traffic of the NBR, the class finally comprised 104 examples constructed by both Cowlairs and the NBL. The whole class would enter British Railways ownership, with the locomotive seen here becoming No. 64596 and be withdrawn in 1961.

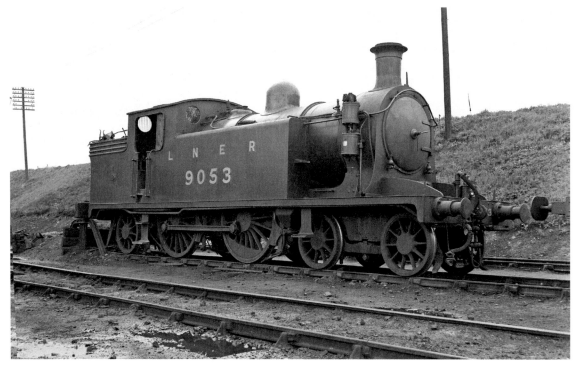

Wednesday 5 May 1937 Seen here at Dunfermline shed is ex-NBR Class M (LNER Class C15) 4-4-2 tank No. 9053. Constructed by the Yorkshire Engine Co. during 1913, she would be withdrawn from service during 1952.

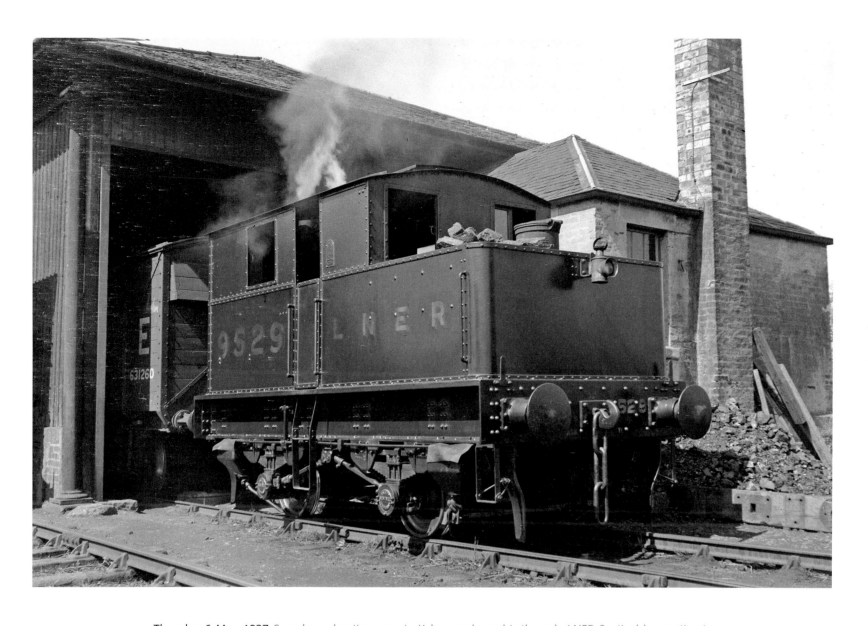

Thursday 6 May 1937 Seen here shunting vans in Kelso goods yard is the only LNER Sentinel locomotive to work in Scotland. Purchased by them during 1927, classified Y1 and numbered 9529, she would later become No. 8138 and finally 68138 under British Railways ownership. By 1928 she would be based at Kelso to work the busy yard there, and it would be 1955 before she moved to Ayr shed from where she would be withdrawn from service in 1959. The LNER purchased over forty examples of these four-wheeled, chain-driven locomotives, to be classified Y1 and Y3, which would be found at work in small yards and departmental sidings throughout the LNER.

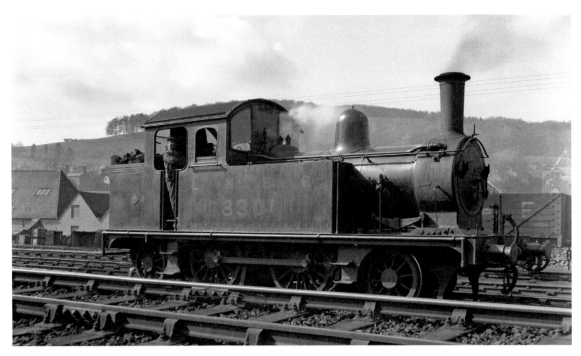

Thursday 6 May 1937 This awkward-looking design of locomotive is ex-GER Class Y65 (LNER Class F7) 2-4-2 tank No. 8301. Constructed at Stratford Works during 1909 to a design by Stephen Holden, and initially utilised on rural branch-line work by both the GER and the LNER, this locomotive would be transferred to the Scottish area in September 1931 and be based at Galashiels for working local branch lines. She would be withdrawn from service during 1943.

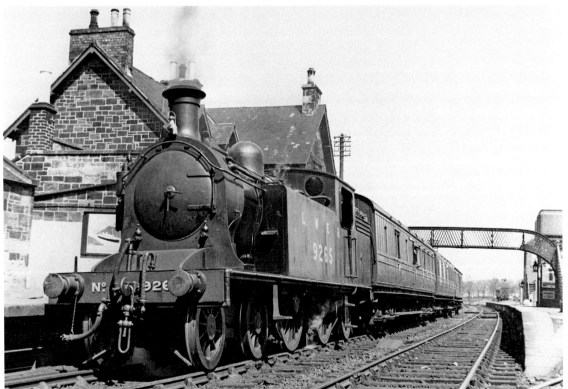

Thursday 6 May 1937 The Tweed Valley Line from its junction at St Boswell's served the important market towns of Kelso and Coldstream on its route to join the East Coast Main Line at Tweedmouth. The Tweed Valley Line opened to traffic during June 1851. Passenger trains ceased in June 1964, with goods traffic being withdrawn during April 1968. Seen here at Kelso station, at the head of the 2.10 p.m. train to St Boswell's, is ex-NBR Class M (LNER Class C15) 4-4-2 tank No. 9265. Built by the Yorkshire Engine Co. in 1913, she was numbered 265 by the NBR, becoming 9265 with the LNER and later No. 7472. With British Railways she would be numbered 67472 and would be withdrawn after forty-three years of service during 1956.

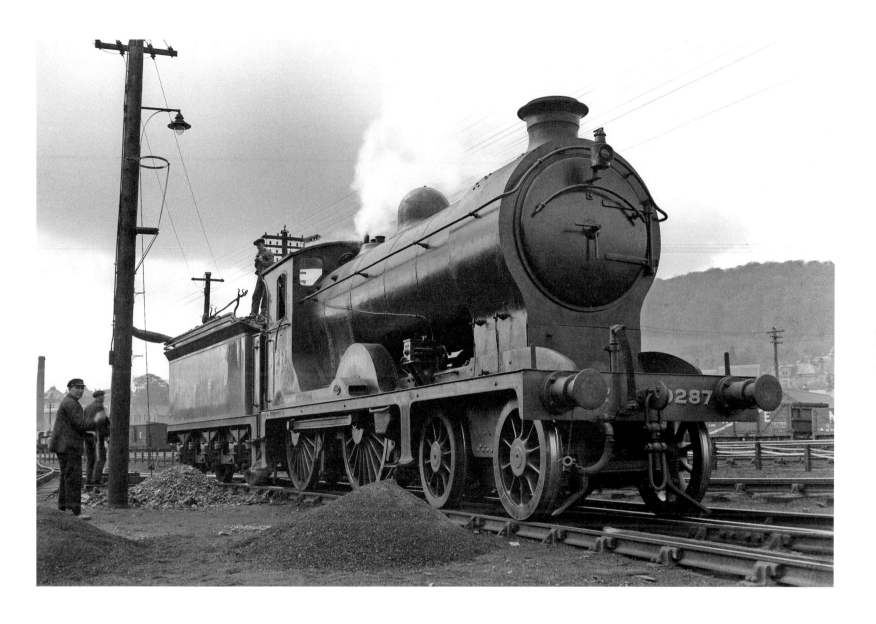

Thursday 6 May 1937 Ex-NBR Class K (LNER Class D34) 4-4-0 No. 9287 *Glen Gyle* is seen taking water whilst in the shed yard at Galashiels. Becoming known as the 'Glens', the class was designed by William Reid and all thirty-two locomotives were constructed at Cowlairs Works between 1913 and 1920. The example seen here entered service during 1919. Long associated with working on the West Highland Line to Fort William and Mallaig, they were still to be seen on that route until the early 1950s. The locomotive seen here was based at St Margarets shed for most of its working life and would become one of the early withdrawals of the class, going during 1946. During 1959 one member of the class, No. 62469 ex-NBR No. 256 *Glen Douglas*, was overhauled and repainted in NBR livery and subsequently used on many special workings. It is currently to be seen at the Scottish Railway Preservation Society museum at Bo'ness.

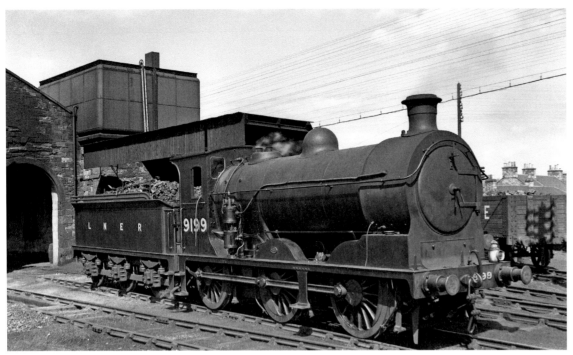

Thursday 6 May 1937 The earlier William Reid design of 0-6-0 goods locomotives for the NBR was the Class B, built with saturated boilers – later Class J35 with the LNER. Constructed in batches between 1906 and 1913 by both the NBL and Cowlairs Works, a total of seventy-six were completed. The locomotive seen here, standing near the shed entrance at St Boswell's, is No. 9199, a product of the NBL during 1909. Equipped with the Westinghouse brake, she would be rebuilt during 1931 with a superheated boiler and be numbered 64486 with British Railways before being withdrawn in 1958.

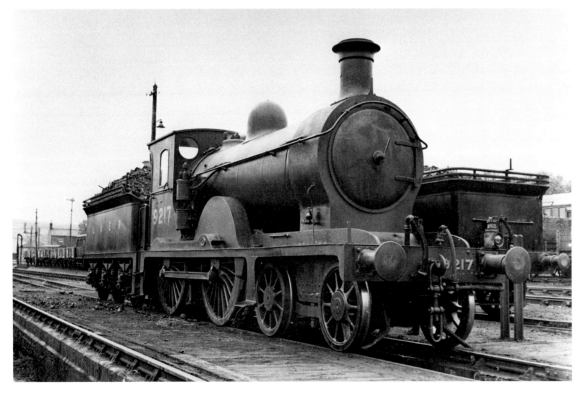

Thursday 6 May 1937 The design of locomotive seen here, ex-NBR Class 633, later Class M (LNER Class D31), 4-4-0s, which utilised 6ft 6in driving wheels, was introduced by Matthew Holmes from 1884. These engines were constructed in batches, all coming from Cowlairs Works, until 1899. Utilised on express passenger work on all the main lines out of Edinburgh and Glasgow, these graceful-looking locomotives were relegated to minor duties as heavier loads and more powerful classes were introduced. Seen here at Riccarton Junction shed is No. 9217. Entering service in 1895, she would be withdrawn during 1939. It should be noted that it was locomotives from this class that took part in the August 1895 races to Aberdeen, achieving exceptional timings on the Edinburgh to Dundee and Aberdeen trains.

Thursday 6 May 1937 Riccarton Junction was a particularly lonely spot to site a railway junction; it not being served by road, the railway community based there had to be very self-sufficient. Although sited on the busy 'Waverley Route' and the junction for the more rural Border Counties Line to Hexham, the locomotive shed was a small affair and basically serviced locomotives before their return duties. Visiting the shed on this day is ex-NBR Class C (LNER Class J36) 0-6-0 No. 9679, sporting a tender weatherboard fitting. This type of fitting could be seen on many locomotives based at locations serving isolated rural lines, as it gave their crews extra protection in adverse weather conditions. This locomotive was the second of a batch constructed by Sharp, Stewart & Co. during 1892. She would survive sixty-five years, to be withdrawn during 1957.

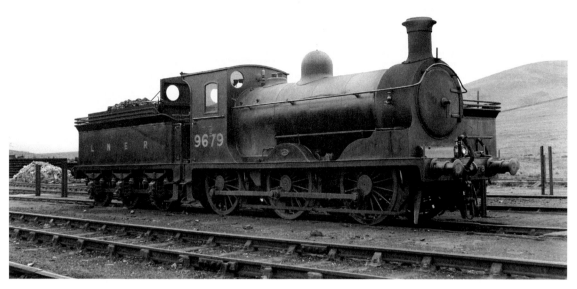

Thursday 6 May 1937 Parked at its home shed, Haymarket in Edinburgh, is LNER Class A3 4-6-2 No. 2506 *Salmon Trout*. Constructed at Doncaster Works and entering service during December 1934, she would be allocated to Haymarket from new and spent most of her working life there, only moving to St Margarets in 1960. Named after the horse that won the 1924 St Leger, she would become the penultimate working example of the class being withdrawn in 1965 numbered 60041.

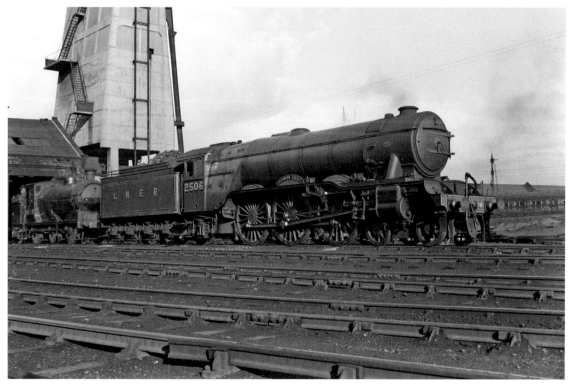

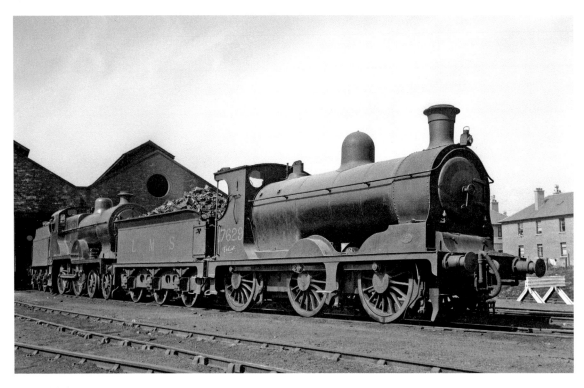

Sunday 1 August 1937 As further goods engines were required by the CR, John McIntosh introduced the Class '652' Standard Goods 0-6-0s, which carried only slight modifications to his earlier Class '812' locomotives. Seventeen examples were constructed by St Rollox Works during 1908 and 1909, the example seen here – No. 17629 – being the first. Numbered 652 by the Caley she would be withdrawn in 1948.

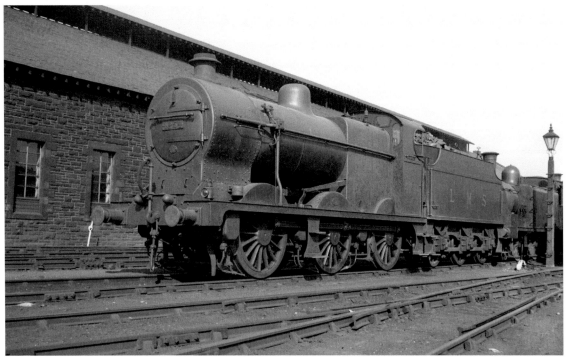

Sunday 1 August 1937 The LM&SR Class 4F 0-6-0s were strong and efficient locomotives that were based on an earlier design by Henry Fowler for the Midland Railway. The LM&SR continued construction of the class, with over 500 examples seeing service with that company. A number were allocated to Scottish area sheds and we see here at Hurlford shed No. 4254. Built at Derby Works during 1926, she would be withdrawn 1962.

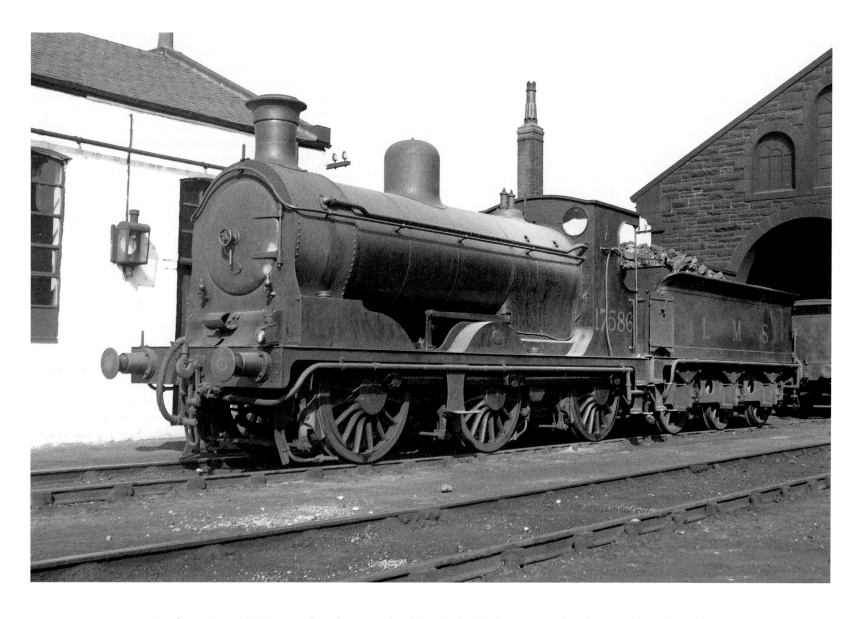

Sunday 1 August 1937 A much earlier example of the 0-6-0 wheel arrangement is also seen here at Hurlford shed. Ex-CR Class '812' No. 17586 was built by Neilson Reid & Co. in 1900. She would become No. 57586 with British Railways and survive sixty-one years, to be withdrawn by them during 1961.

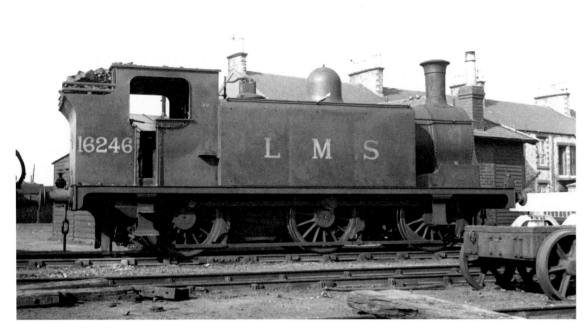

Sunday 1 August 1937 Another John McIntosh introduction for the Caledonian were the Class '782' Standard Shunting 0-6-0 tanks which first appeared from St Rollox Works during 1898. The final total of 120 examples indicates how useful these locomotives were and building continued until 1913, with examples being employed in goods yards throughout the old Caley system. Seen here at Hurlford shed is No. 16246, which was an 1899 example that would be withdrawn by British Railways during 1961 numbered 56246.

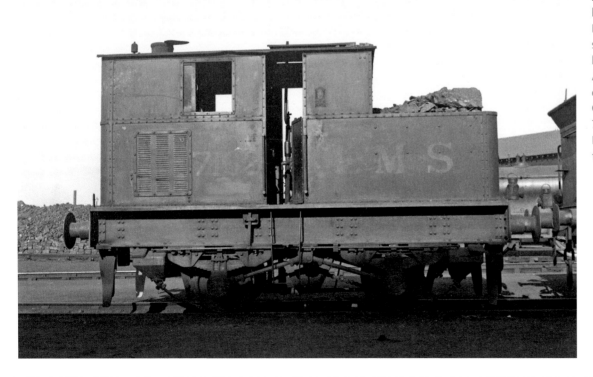

Sunday 1 August 1937 The use of Sentinel locomotives in Scotland was rare with the LNER only using one example. The LM&SR similarly utilised one locomotive which was based at Ayr for many years. Seen here at Ayr shed is No. 7162, the third of a batch of four constructed in 1930 by the Sentinel Co. for them. She would later be numbered 7182 by the LM&SR and finally 47182 by British Railways, who would withdraw her from service in 1956.

Sunday 1 August 1937 Seen here parked in the yard at Ayr shed is ex-CR Class '812' 0-6-0 No. 17611. One of a batch of fifteen examples of this class constructed by Dübs & Co. during 1900, she would survive sixty-one years, to be withdrawn by British Railways numbered 57611 in 1961.

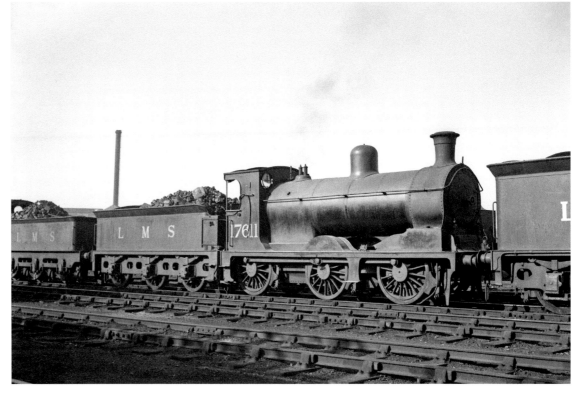

Sunday 1 August 1937 Another Class '812' in the yard at Hurlford shed. No. 17602 was a product of Dübs & Co. during 1900 that would be withdrawn in 1962.

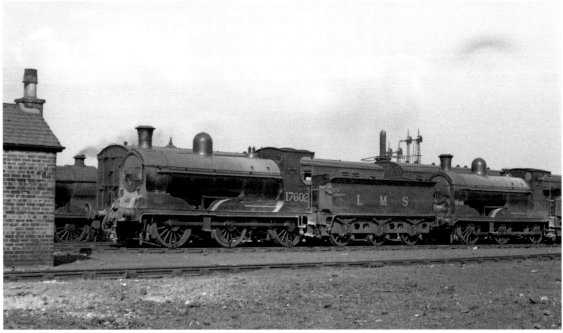

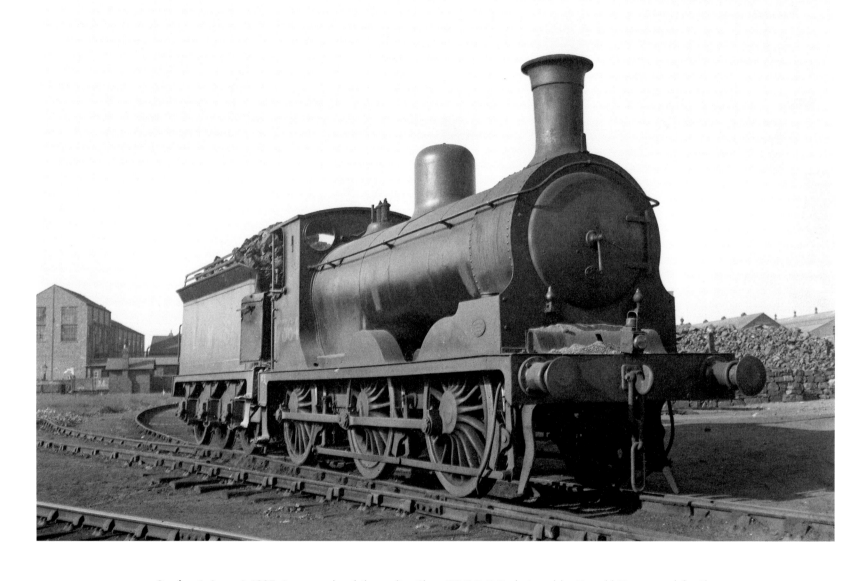

Sunday 1 August 1937 An example of the earlier Class '294' 0-6-0, designed by Dugald Drummond for the Caledonian, is seen here at Ayr shed. LM&SR No. 17364 was a St Rollox Works-built example of 1887 that would be withdrawn during 1948.

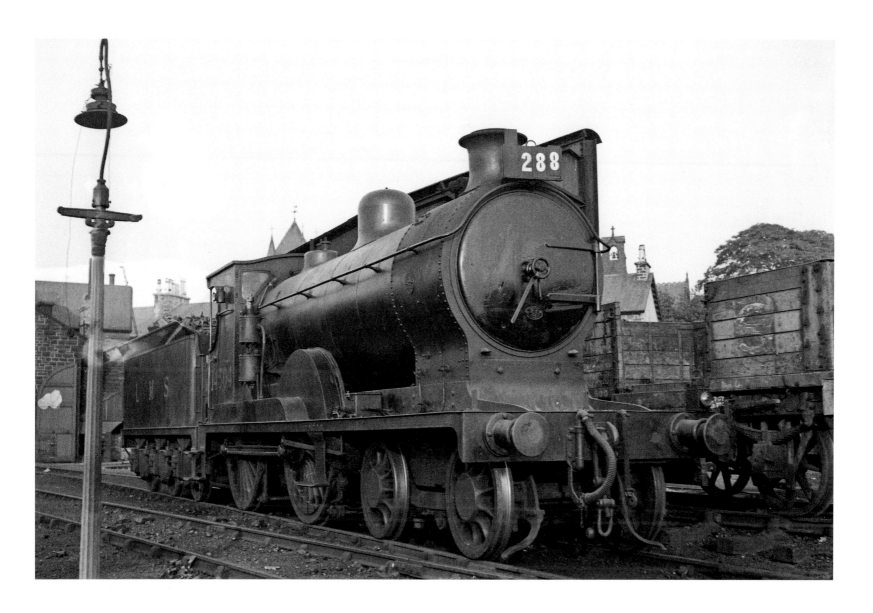

Sunday 1 August 1937 William Pickersgill succeeded John McIntosh as the locomotive superintendent with the CR in 1914, and he continued and improved the well-established McIntosh design of 4-4-0s. Constructed with slightly larger cylinders, stronger frames and a higher nominal tractive effort than the McIntosh designs, the first batch of sixteen examples of the Pickersgill Class '113' 4-4-0s were delivered from both St Rollox Works and the NBL during 1916. These were followed by ten further locomotives in 1920 from St Rollox, ten more from Armstrong Whitworth during 1921 and finally twelve examples from the NBL during 1922, all designated Class '72' by the Caley. Designed to be utilised on express passenger traffic, during LM&SR days they could be found working as far north as Wick and Thurso on ex-HR territory and as far south as Stranraer on ex-G&SWR ground. The locomotive seen here at Muirkirk shed in Ayrshire is No. 14504, one of the NBL 1922-built examples that would be withdrawn during 1959.

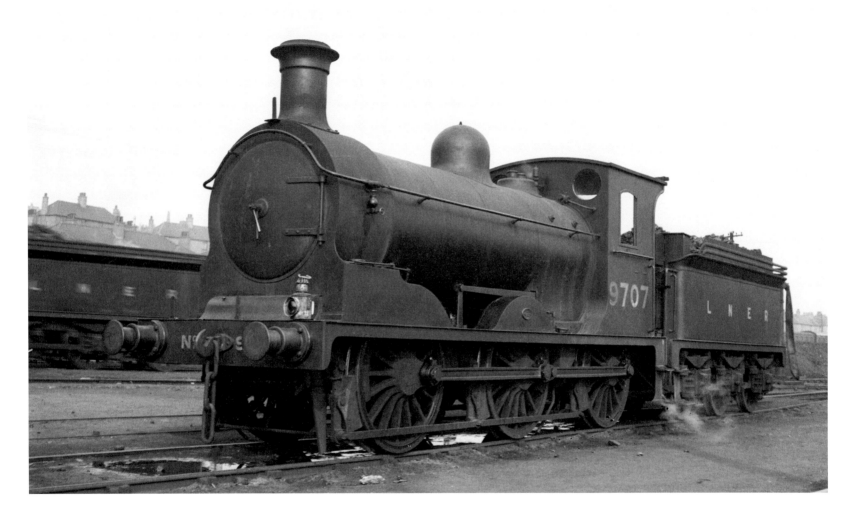

Monday 2 August 1937 Seen here at Bathgate shed are three examples of the well-balanced design of ex-NBR Class C (LNER Class J36) 0-6-0. Designed by Matthew Holmes and constructed in batches from 1888 until 1900, a total of 168 examples were to be seen in use all over the NBR system. All of the locomotives in the class were rebuilt in the form seen here, with Reid-style cabs. So useful and reliable was this class that many examples continued in use until the 1960s, with the last two examples of main-line steam locomotives to be withdrawn in Scotland during 1967 being both J36s. *Above*: No. 9707, a Cowlairs Works-built example from 1896, would be withdrawn in January 1952. *Above right*: No. 9248, another Cowlairs Works-built locomotive from 1892, would be withdrawn after seventy-one years of service during December 1963. *Below right*: No. 9752, yet another Cowlairs Works example from 1899, managed to serve for sixty-three years and was withdrawn in July 1962.

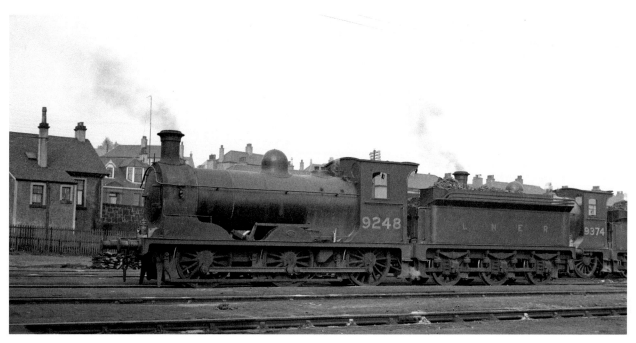

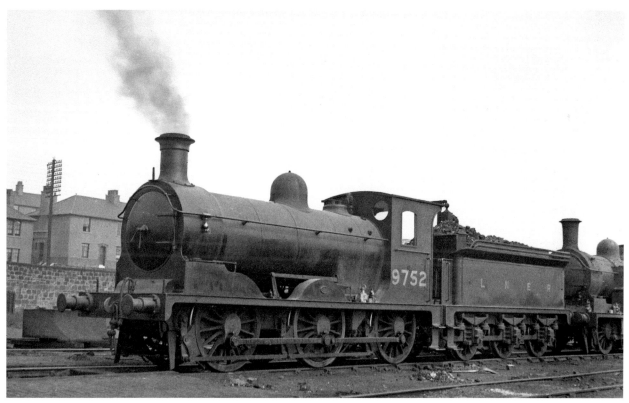

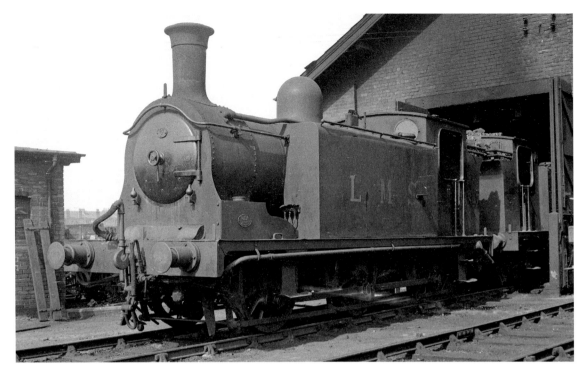

Monday 2 August 1937 Ex-CR Class '782' 0-6-0 tank No. 16347 is seen standing at the entrance to Yoker shed in Glasgow. Constructed by St Rollox Works during 1912, she would be withdrawn in 1962 numbered 56347 by British Railways.

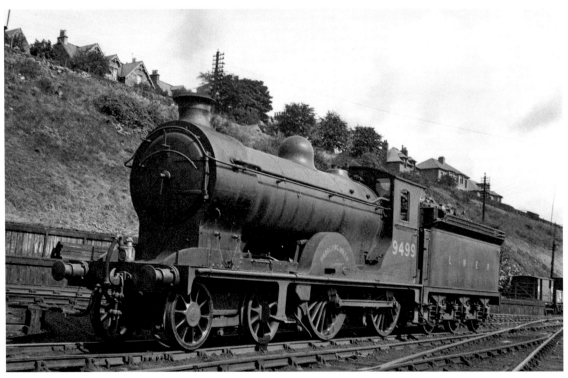

Sunday 15 August 1937 Following the success of his 'Scott' Class J (LNER Class D29) 4-4-0 locomotives for the NBR, William Reid designed a version that incorporated a superheated boiler. Classified D30 by the LNER, the first two examples of these 'Superheated Scotts' appeared in 1912, with the bulk of the class following during 1914 and 1915. The last five examples were built in 1920, all coming from Cowlairs Works. Utilised on express passenger traffic from Glasgow and Edinburgh to Dundee and Perth, they also found much work on the 'Waverley Route', which was most appropriate, since the whole class was named after characters from the works of Sir Walter Scott. Seen here at Hawick shed is No. 9499 *Wandering Willie*. Entering service in 1920, she would be withdrawn by British Railways in 1958 numbered 62440. The character Wandering Willie appears in the 1824-published historical novel *Redgauntlet*.

Sunday 26 June 1938 Parked in the yard at Polmadie shed in Glasgow, this impressive-looking locomotive is a rare example of a Pacific tank. Ex-CR Class '944' 4-6-2 tank No. 15351 was one of a class of twelve locomotives designed by William Pickersgill intended for use on the passenger traffic between Glasgow and the Clyde coast towns. Built by the NBL and delivered between March and May 1917, these locomotives were found more useful work during the war period, and it was not until hostilities ceased that they finally did the work they were intended for. The locomotive seen here was based at Polmadie until transferred to Beattock in 1947 to undertake banking duties there. She would be withdrawn from service in 1948.

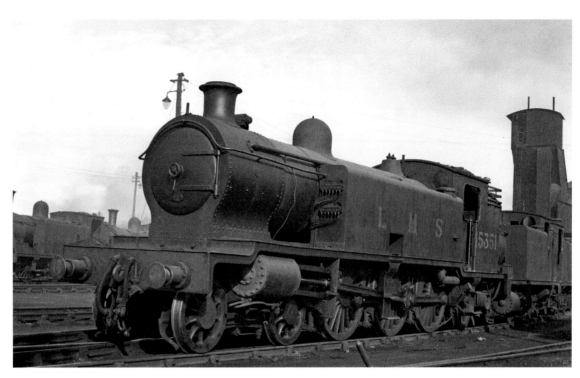

Tuesday 28 June 1938 Parked in the yard at Perth South shed is ex-HR 'River' Class 4-6-0 No. 14759. The circumstances of the design, construction and delivery of the class to that railway are somewhat clouded. Designed by Frederick Smith in conjunction with R.&W. Hawthorn Leslie & Co. in Newcastle, the six examples of the class were completed and delivered during 1915. After delivery of the first two locomotives and their testing on Highland metals, the chief engineer of the HR refused to sanction their use; in consequence, all six locomotives were sold to the CR in the same year and became, reportedly, some of the best-performing 4-6-0s owned by that company. After the grouping, the LM&SR allowed their use on the ex-Highland Main Line north of Perth, so in their later years they were finally utilised on the traffic they were originally designed to handle. The locomotive seen here would be withdrawn in January 1939, eight months after this photograph was taken.

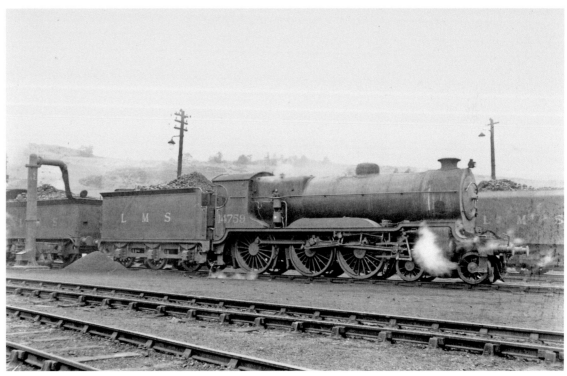

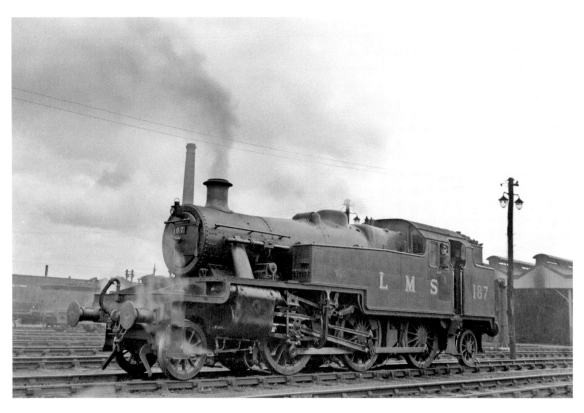

Tuesday 28 June 1938 Barely eight months into her service life, LM&SR Class 3P 2-6-2 tank No. 187 is seen here at Perth South shed. Constructed at Crewe Works to a design by William Stanier, a total of 139 examples of the class were built by both Crewe and Derby Works over a period of three years from 1935. Initially allocated to Perth shed, the locomotive seen here would be withdrawn in 1962, whilst based at Motherwell shed and numbered 40187.

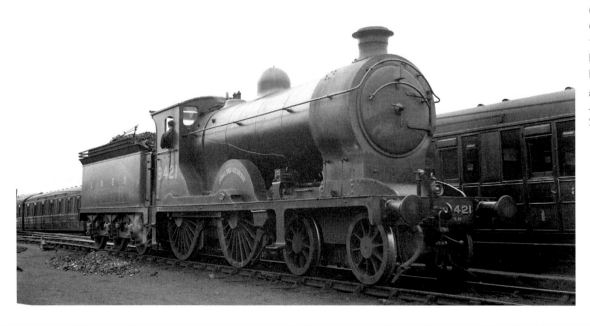

Tuesday 28 June 1938 Waiting to leave Dundee Tay Bridge shed is ex-NBR Class J (LNER Class D30) 4-4-0 No. 9421 *Jingling Geordie*. Built at Cowlairs Works during 1914, she would become No. 62430 with British Railways and be withdrawn in 1957. Named after the well-known Edinburgh goldsmith and character George Heriot, Jingling Geordie, who appears in the 1822 Scott novel *The Fortunes of Nigel*.

Wednesday 29 June 1938 Purchased by the GNoSR specifically to work the lines owned by the Aberdeen Harbour Trust, the four 0-4-2 tanks comprising Class Y (LNER Class Z5) and Class X (LNER Class Z4) were delivered from Manning Wardle & Co. during 1915, the only differences in their design being the smaller driving wheels and reduced weight of the Z4s. These locomotives, two in each class, were a familiar sight working around the quays, and although they spent virtually all their working lives there, a rare occasional hiring to industrial sites in Scotland did take place. Seen here at Kittybrewster shed is Class Z4 No. 6844, later to become No. 68191 with British Railways and to be withdrawn from service during 1959.

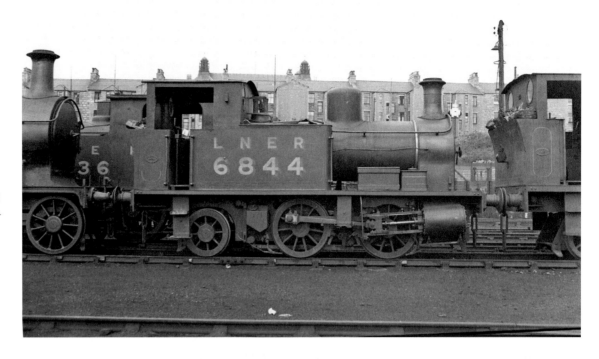

Wednesday 29 June 1938 With a graceful curve to the splashers, a slender, slightly tapering chimney and a tall dome, the splendid locomotive seen here at Kittybrewster shed is ex-GNoSR Class V (LNER Class D40) 4-4-0 No. 6825. Designed by William Pickersgill and constructed by Neilson Reid & Co. during 1899, she would be withdrawn by British Railways in 1953 numbered 62260.

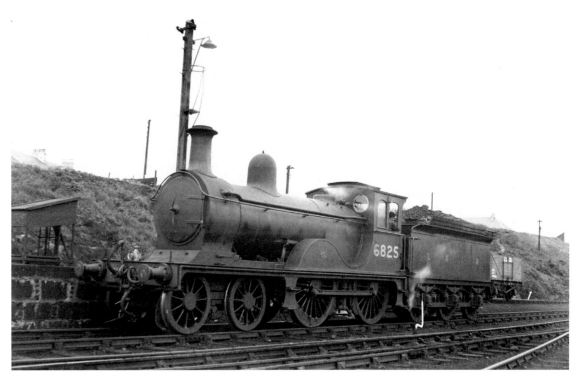

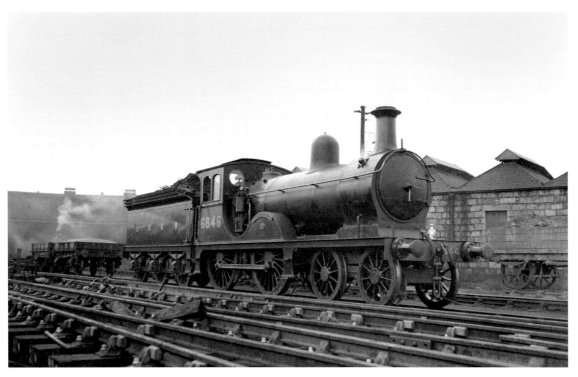

Wednesday 29 June 1938 With the half roundhouse at Kittybrewster in the background, ex-GNoSR Class F (LNER Class D40) 4-4-0 No. 6846 *Benachie* is seen in beautifully clean condition as she waits to leave the shed. The very last locomotive to be constructed at Inverurie Works for the GNoSR, she appeared as late as 1921 during the tenure of Thomas Heywood, the locomotive superintendent at that time. The design was based on the earlier William Pickersgill Class V unsuperheated locomotives, the Class F variant using superheated boilers. She would be numbered 62274 with British Railways and be withdrawn in 1955. It is fortunate that a representative of the class has been preserved – No. 62277, GNoSR No. 49 *Gordon Highlander* now resides in the Glasgow Museum of Transport.

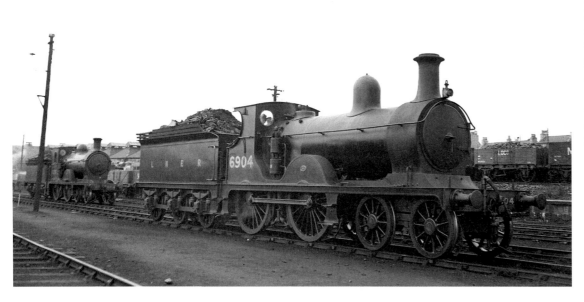

Wednesday 29 June 1938 Another locomotive seen here waiting to depart from Kittybrewster shed is ex-GNoSR Class T (LNER Class D41) 4-4-0 No. 6904. She is an example of the earlier design of locomotive with this wheel arrangement, originally by James Johnson and refined by William Pickersgill, which was introduced in 1893. The locomotive seen here entered service from Neilson & Co. during 1897 and, numbered 62248, would be withdrawn by British Railways during 1952. Notice the different cab design to the locomotive in the previous photograph.

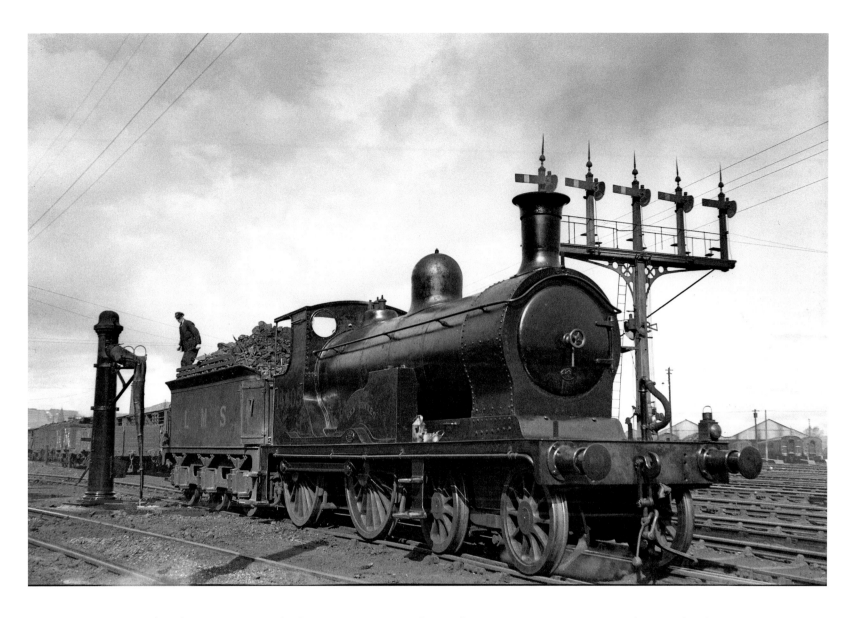

Thursday 30 June 1938 The fireman on ex-HR 'Small Ben' Class 4-4-0 No. 14405 *Ben Rinnes* has completed the watering and the driver's oil feeders are still on the running board, which would indicate that the locomotive is being made ready for its next duty. She was the first of a batch of nine locomotives of the class to be constructed at the Highland's own works at Lochgorm during 1899. Seen here at Inverness in rebuilt form with a Caledonian-type boiler, she would be withdrawn from service in 1944. Note the impressive array of lower quadrant home signals in the background.

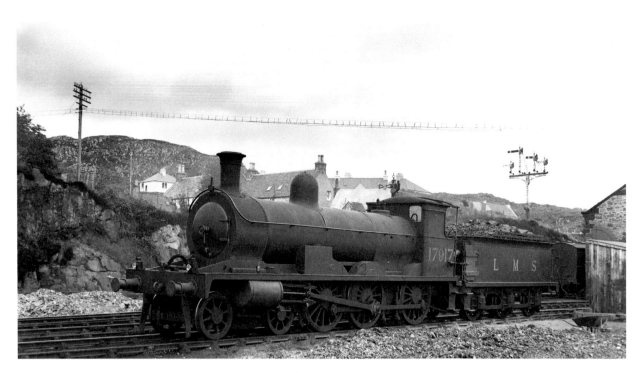

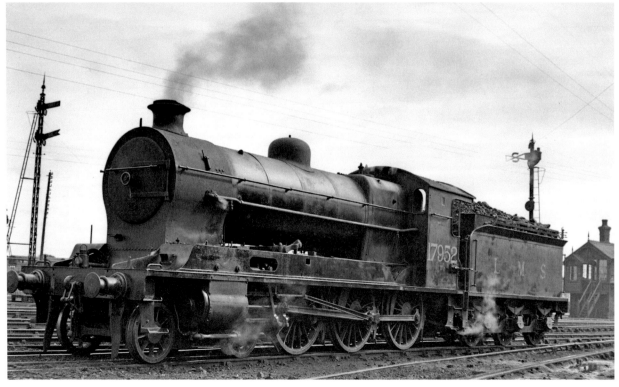

Thursday 30 June to 1 July 1938 The three photographs comprising this spread show the progression in the design of locomotives using the 4-6-0 wheel arrangement that worked on Highland metals. Top left is ex-HR 'Big Goods' Class No. 17917, seen at Kyle of Lochalsh shed on 30 June. The second member of this groundbreaking class to be constructed by Sharp, Stewart & Co. and introduced during 1894, she was numbered 104 by the Highland and would be withdrawn in 1939. *Bottom left*: Seen at Inverness shed on the same day is an example of the Christopher Cumming-designed 'Superheated Goods' No. 17952. Built by R.&W. Hawthorn Leslie & Co. and introduced twenty-four years after the 'Big Goods' in 1917, she would be withdrawn during 1946. *Above*: Seen here waiting to depart from Inverness with a southbound train on Friday 1 July is William Stanier-designed 'Black Five' No. 5174. An early example of this class, constructed by Armstrong Whitworth & Co. in 1935, she would be withdrawn during 1962 numbered 45174. The management of the LM&SR was forward-thinking enough to lay aside the first member of the 'Big Goods' class, No. 103, for preservation, and she can now be seen at the Museum of Transport in Glasgow.

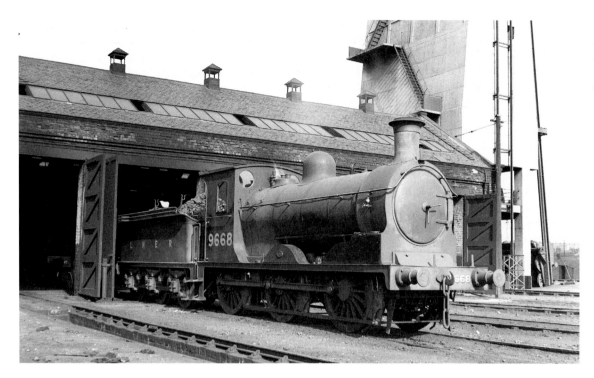

Friday 1 July 1938 Parked at the western entrance to Haymarket shed is ex-NBR Class C (LNER Class J36) 0-6-0 No. 9668, built by Neilson & Co. during 1891. She would give sixty-one years of service before being withdrawn by British Railways in 1952 numbered 65240.

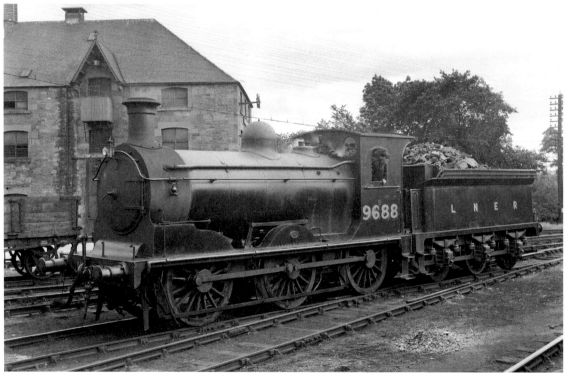

Saturday 12 August 1939 Classmate to the locomotive in the previous photograph, No. 9688 is seen here at St Boswell's shed. A product of Sharp, Stewart & Co. and entering service during 1892, she would survive for sixty-seven years, to be withdrawn in 1959 numbered 65259.

Saturday 12 August 1939 Waiting to depart from St Boswell's station with a southbound 'stopper' from Edinburgh to Carlisle is ex-NBR Class J (LNER Class D30) 4-4-0 No. 9413 *Caleb Balderstone*. Built at Cowlairs Works in 1914 and named after the butler character in the 1819 Scott novel *The Bride of Lammermoor*, she would be withdrawn in 1958 by British Railways numbered 62422.

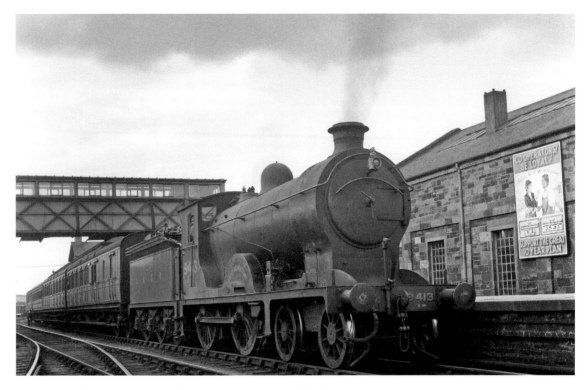

Saturday 12 August 1939 Standing in the down-bay platform at Hawick station is LNER Class D49/1, three-cylinder 4-4-0 No. 311 *Peebles-shire*. Later numbered 2719 by the LNER and finally 62719 by British Railways, she was constructed at Darlington Works and entered service during 1928. An early member of the class, she was fitted with Walschaerts valve gear. Later class members would be fitted with Lentz Rotary or Oscillating Cam valve gear. Spending most of her working life based at Haymarket shed in Edinburgh, she would be withdrawn in 1960.

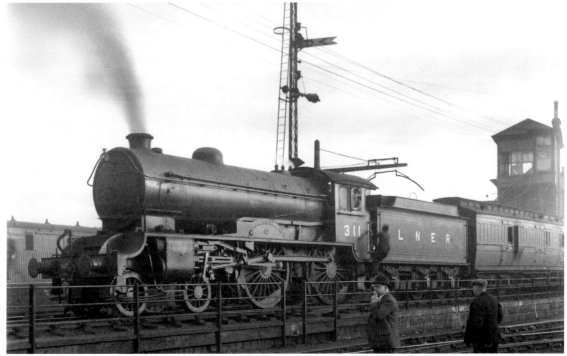

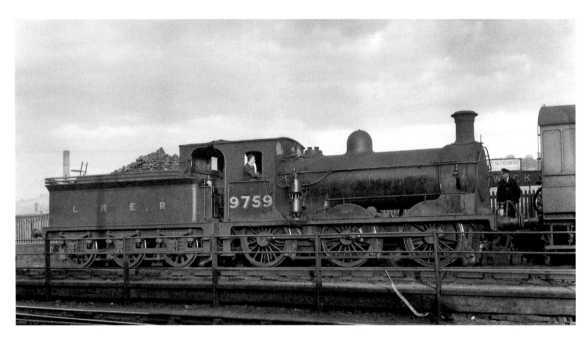

Saturday 12 August 1939 Ex-NBR Class C (LNER Class J36) 0-6-0 No. 9759 is parked in the down bay at Hawick station. One of the Cowlairs Works-constructed members of this class from 1899, she is seen here equipped with a tender cab fitting. She would be withdrawn during 1960 numbered 65317.

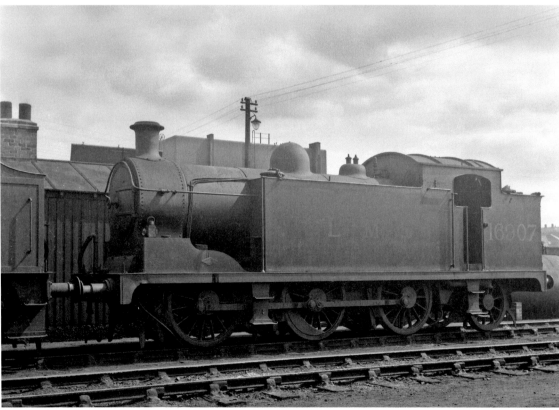

Sunday 13 August 1939 Ex-G&SWR Class '1' 0-6-2 tank No. 16907 is seen here at Kingmoor shed in Carlisle. Built by the NBL during 1919 she would become one of the last members of the class to be withdrawn during 1945. During 1936 the LM&SR sold two classmates, Nos 16903 and 16910, to Robert McAlpine & Sons Ltd to work on their contract constructing the Ebbw Vale steelworks in South Wales.

Sunday 13 August 1939 This impressive-looking locomotive is Class '60' 4-6-0 No. 14643. Seen here at Kingmoor shed, she was an example of the CR class constructed during LM&SR days at St Rollox Works. Coming into service in 1926, she would be withdrawn during 1949.

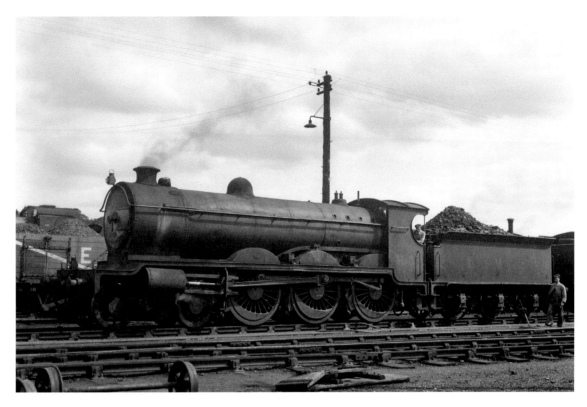

Wednesday 3 April 1946 It may be April, but ex-HR 'Superheated Goods' Class 4-6-0 No. 17950 is still carrying a small snowplough. Standing outside the roundhouse at Inverness, she is looking rather grimy. She was the first of the class to be delivered from R.&W. Hawthorn Leslie & Co. during 1917. She would be numbered 57950 by British Railways and be withdrawn in 1950.

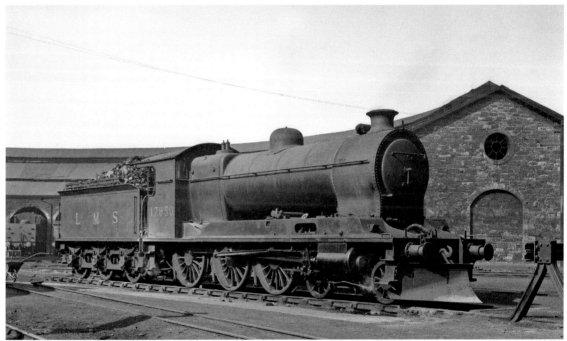

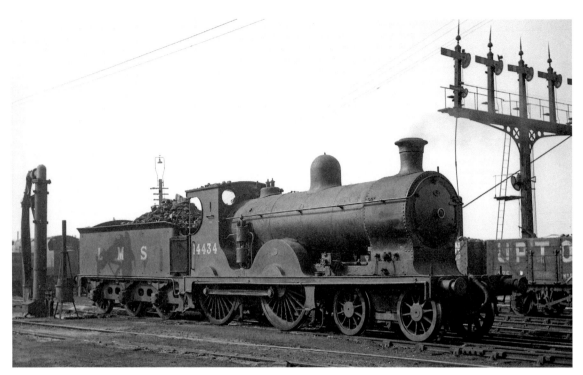

Wednesday 3 April 1946 Sitting in the yard at Inverness shed looking rather forlorn is an ex-Caley greyhound. Class '900' 4-4-0 No. 14434 is an example of the 'Dunalastair III' locomotives designed by John McIntosh and introduced in 1899. Entering service in 1900, she would be numbered 894 by the Caledonian and would be utilised on express passenger trains. Being rebuilt with a superheating boiler during 1916, she would by the time of this photograph be allocated to Aviemore shed and be withdrawn from service during 1948.

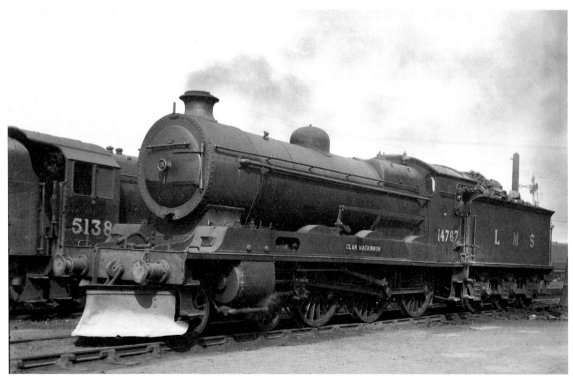

Wednesday 3 April 1946 The first four examples of the HR 'Clan' Class 4-6-0s were introduced to service during 1919, with a further four locomotives arriving during 1921. Seen here at Inverness shed, again fitted with a small snowplough, is No. 14767 *Clan Mackinnon*. Numbered 55 by the Highland she was one of the 1921-built batch. She would be the only member of the class to bear a British Railways allocated number, 54767, and the last of the class to be withdrawn in 1950.

Wednesday 3 April 1946 In the immediate post-war period, the overall appearance of locomotives took a turn for the worse, as labour for cleaning had been drastically reduced during the war. Seen here at Dingwall is a rather grubby-looking ex-HR 'Small Ben' Class 4-4-0 No. 14404 *Ben Clebrig*. The last member of the class to be constructed by Dübs & Co. during 1899, she is carrying the distinctive diamond-shaped builders' plate on the front splasher. A further twelve members of the class were built at Lochgorm Works and the NBL between 1899 and 1906. The locomotive pictured here was one of the longer-serving members of the class. She was a bit of a nomad, based at Aviemore, Keith, Inverness and Wick throughout her life. Numbered 54404 by British Railways, she would be withdrawn in 1950.

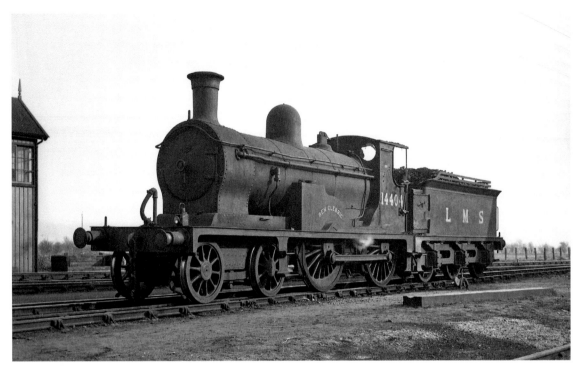

Thursday 4 April 1946 The HR only ever owned and operated twelve tender locomotives that utilised the 0-6-0 wheel arrangement. Constructed by Dübs & Co. and their successors the NBL, the first examples of the Class '18' or 'Drummond Goods' were delivered during 1900, with further locomotives arriving in 1902 and 1907. The example seen here, No. 17702, was one of the 1902 batch of four locomotives, fitted with a water tube firebox which would later be removed during rebuilding with a Caledonian-style boiler, as seen here. This locomotive would be withdrawn from service during 1949.

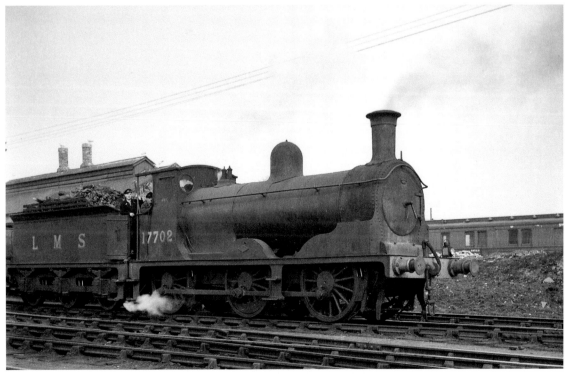

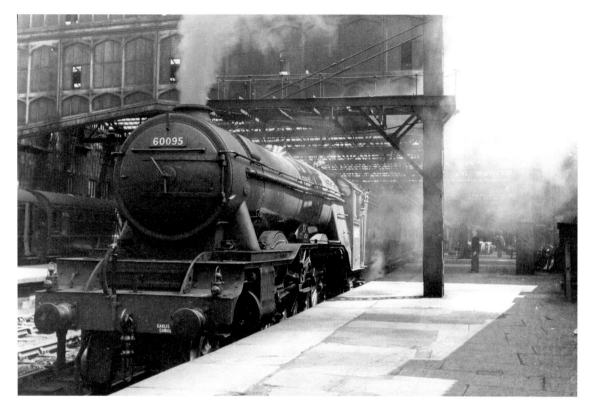

Friday 2 June 1950 The locomotive seen here waiting to depart from Carlisle station is long-term Carlisle Canal shed resident LNER Class A3 4-6-2 No. 60095 *Flamingo*. Named after the horse that won the 1928 2,000 Guineas race, she was constructed at Doncaster Works during 1929 and allocated new to Canal shed, spending her entire working life based there. A number of A3s were allocated there to cover workings over the 'Waverley Route' to Edinburgh. Seen here still wearing her post-war green livery, she would be withdrawn in 1961.

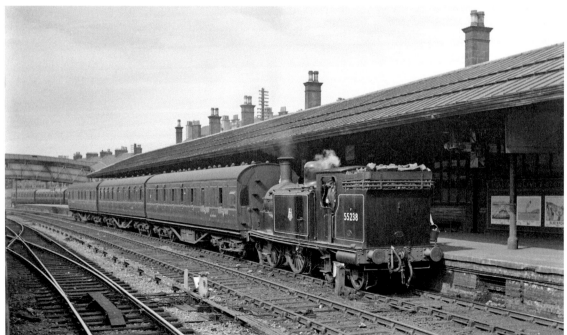

Friday 2 June 1950 Waiting to depart from Larbert station with a working to Grangemouth is ex-CR Class 'Enlarged 439' 0-4-4 tank No. 55238, looking splendid in its new British Railways-lined livery. An example of a batch of four locomotives built at St Rollox Works during 1922, and specially strengthened for banking duties at Beattock, she had slightly larger cylinders and extra-thick buffer beams. Note the addition of a wooden coal rail on the bunker to increase the coal-carrying capacity. This locomotive was transferred from Beattock to Grangemouth during the early post-war period and would be withdrawn in 1961.

Friday 2 June 1950 Bearing its new British Railway number and corporate identity on the tender, ex-LM&SR Class 4P three-cylinder 4-4-0 Compound No. 40903 is seen shunting some stock at Carstairs station. Constructed by the Vulcan Foundry during 1927, she would be numbered 903 by the LM&SR and allocated to Polmadie shed in Glasgow. By 1948 she would be resident at Carstairs shed and would be withdrawn in 1955.

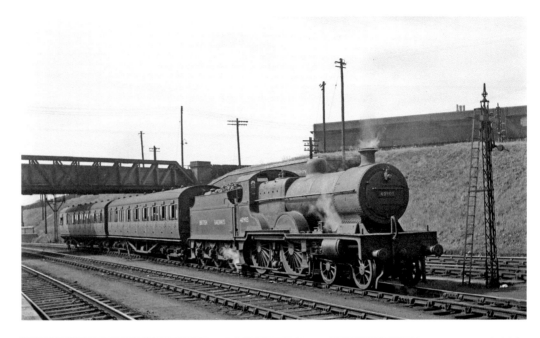

Friday 2 June 1950 With a full head of steam and looking particularly clean, ex-LM&SR Class 5 4-6-0 No. 44923 pauses at Stirling station at the head of a northbound express. She had only recently emerged from a works visit, newly painted and with her new number applied. A Crewe Works-built example of the class, entering service in 1946, she would be withdrawn during 1964. A total of 842 examples of the class would be constructed from their introduction in 1935 until 1951, when the last came into service.

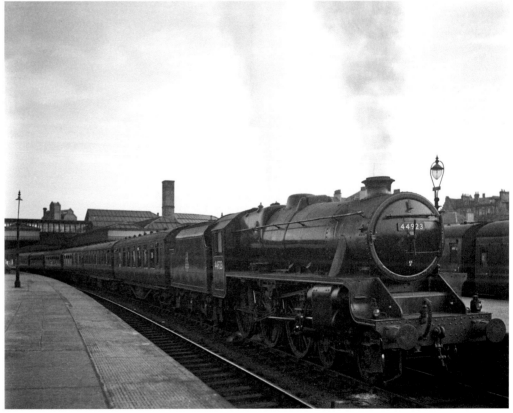

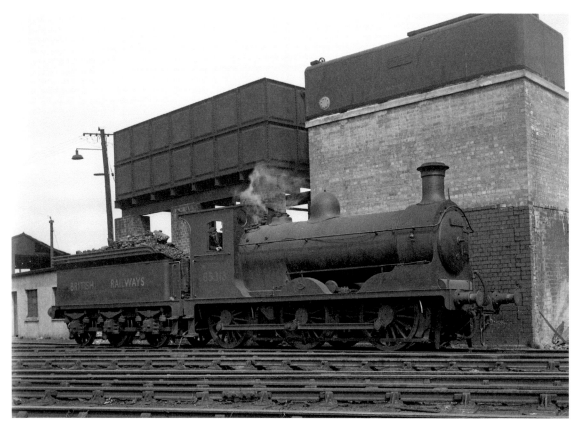

Sunday 11 June 1950 Two examples of the ex-NBR Class C (LNER Class J36) 0-6-0 are seen here at Fort William shed. *Above*: Dwarfed by the water towers, No. 65313 was a long-term resident at this shed. She was a Cowlairs Works-built example, entering service during 1899; *Below*: No. 65237, the first of a batch of Neilson & Co.-constructed examples of the class delivered in 1891. Note the tender cab fitted to this example. No. 65313 would be withdrawn in 1962 having given sixty-three years of service, but No. 65237 managed a total of seventy-one years before going for scrap during 1962.

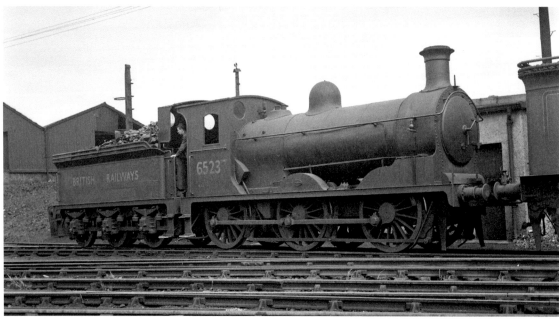

Sunday 11 June 1950 The first of a class of six locomotives designed by Nigel Gresley for the LNER, specifically to reduce the need for the double-heading of trains on the West Highland Line, the Class K4 three-cylinder 2-6-0s proved to be well up to managing trains unassisted. Seen here at Fort William shed is No. 61993 *Loch Long*, delivered from Darlington Works to Eastfield shed in 1937. It would be 1959 before she would be allocated away from West Highland duties to be based at Thornton Junction shed, from where she would be withdrawn in 1961.

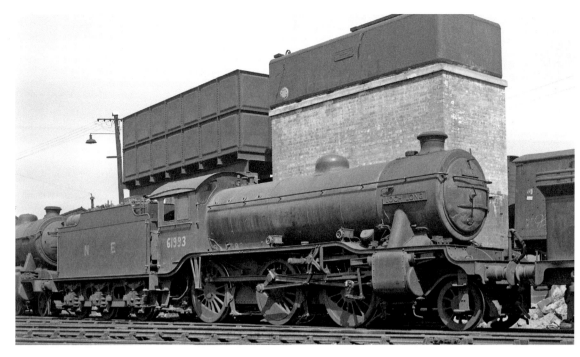

Sunday 11 June 1950 Another earlier Gresley design, ex-GNR Class H3 (LNER Class K2) 2-6-0 No. 61775 *Loch Treig* is parked below the water towers at Fort William shed. Constructed by Kitson & Co. during 1921, she would be allocated to Eastfield shed during 1931–32 to work on the West Highland Line and subsequently named during 1933. Withdrawal would come in 1958.

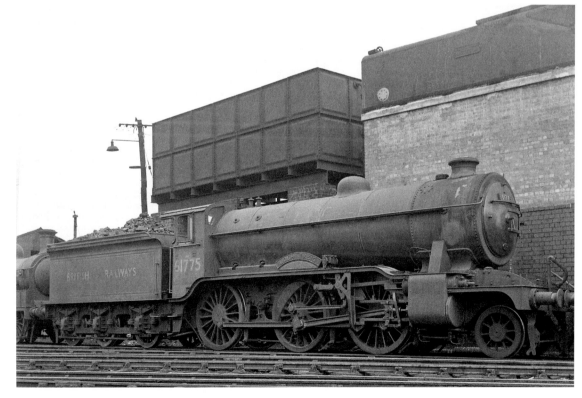

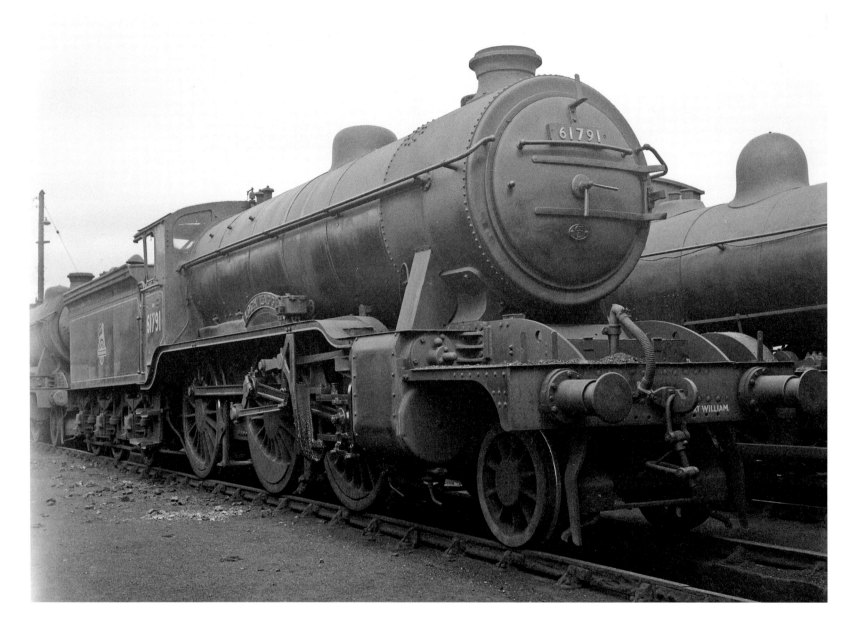

Sunday 11 June 1950 Parked at Fort William shed are three sisters: ex-GNR Class H3 (LNER Class K2) 2-6-0 Nos 61791 *Loch Laggan* (*above*), 61792 (*top right*) and 61793 (*bottom right*). No. 61791 clearly bears her home shed name painted on the front buffer beam, she also bears the earlier Fort William shed code 63D, which became, during the early 1960s, 63B. She would acquire her name during 1933, when all thirteen members of the class allocated to work over the West Highland route were named after lochs adjacent to the line.

No. 61792 was an unnamed example. Note the flattened type of dome cover used. No. 61793 was also an unnamed member of the class that had been allocated to St Margarets shed in Edinburgh during 1925, later finding herself allocated to Eastfield shed. By 1952 she would be working on the ex-GNoSR section based at Keith. The three locomotives were constructed by Kitson & Co. of Leeds during 1921. Withdrawals would take place in March 1960 for 61791, September 1960 for 61792 and February 1959 for 61793.

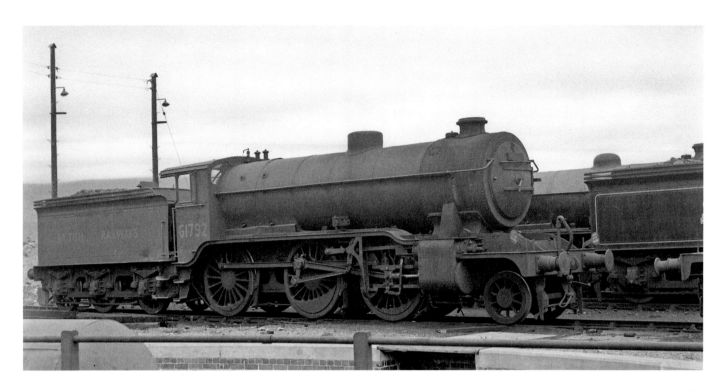

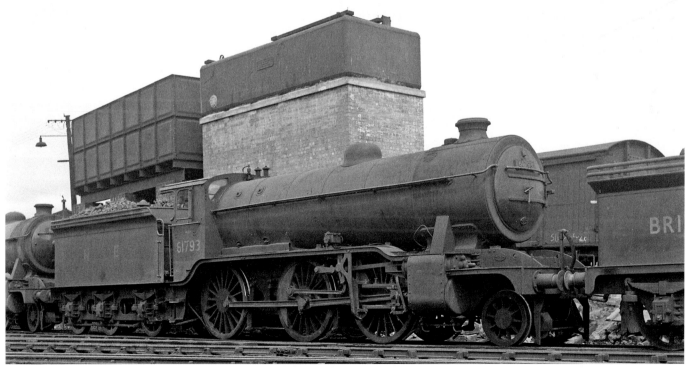

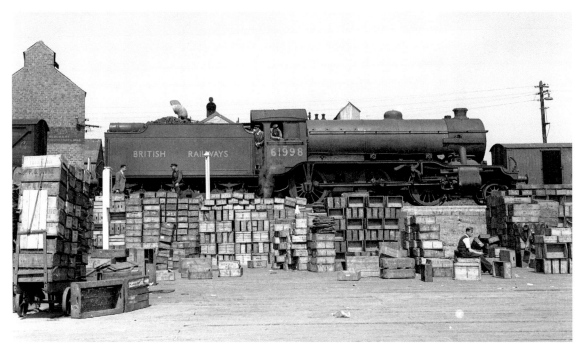

Monday 12 June 1950 The crew of ex-LNER Class K4 2-6-0 No. 61998 *MacLeod of MacLeod* wait patiently for fish vans to be loaded whilst sitting in the sidings at Mallaig harbour. Constructed at Darlington Works and entering traffic during 1939 she would be allocated to Eastfield shed to work the West Highland Line, spending most of her working life on this route before being withdrawn from service in 1961.

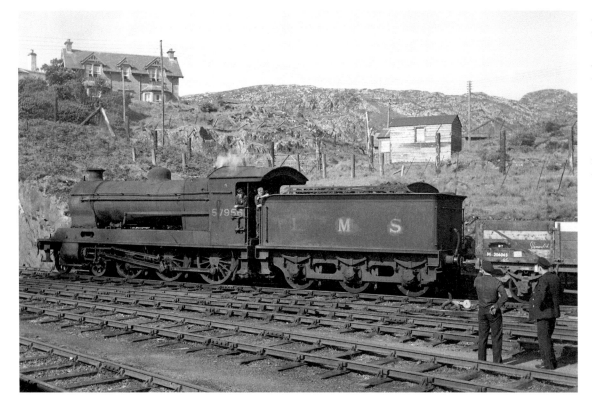

Monday 12 June 1950 Another crew is seen here waiting for instructions, and a rather dirty ex-HR 'Superheated Goods' 4-6-0 No. 57956 pauses whilst shunting wagons at Kyle of Lochalsh, bearing her new British Railways number but with her previous owner's initials still on the tender. She was the product of R.&W. Hawthorn Leslie & Co. during 1919 and would see thirty-three years of service, being withdrawn in 1952.

Tuesday 13 June 1950 One of the earliest examples of the Stanier 'Black 5' 4-6-0s, seen here at Inverness shed, is No. 45018, a Crewe Works-built locomotive of 1935. Bearing a 60B Aviemore shed plate, she would be withdrawn during 1966. Members of the class were not only constructed at Crewe, Horwich and Derby Works; two independent locomotive builders, the Vulcan Foundry and Armstrong Whitworth, also built many examples.

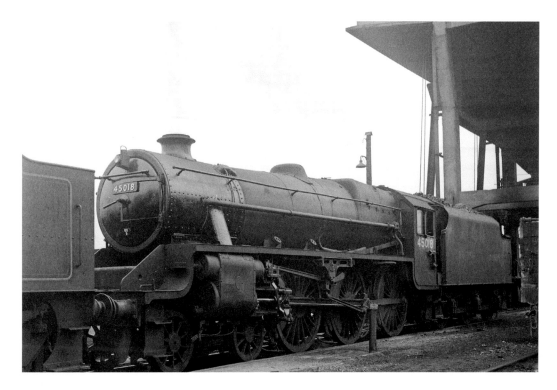

Tuesday 13 June 1950 In beautifully turned-out condition, ex-GNR Class H3 (LNER Class K2) 2-6-0 No. 61782 *Loch Eil* waits at the platform end at Fort William station before coupling up to the train which will be its next working to Mallaig. Another 1921-built Kitson & Co. example of the class to be allocated to Fort William shed, she would during the later 1950s be allocated to Keith shed before being withdrawn in 1960.

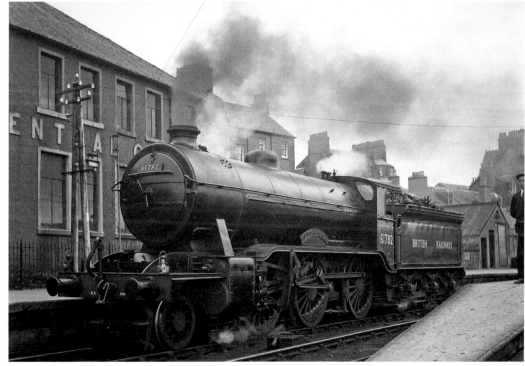

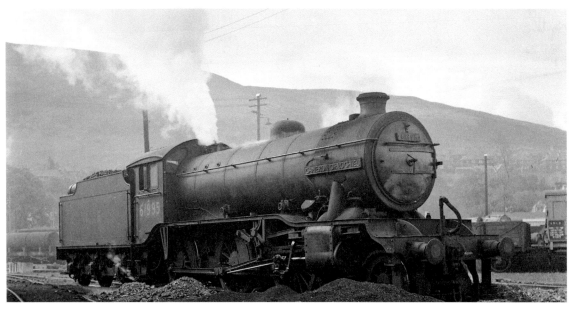

Wednesday 14 June 1950 Ex-LNER three-cylinder Class K4 No. 61995 *Cameron of Lochiel* is seen sitting amongst the piles of firebox ash and smokebox char at Fort William shed. Built at Darlington Works during 1938, she would be allocated to Fort William shed for most of her working life and be withdrawn in 1961.

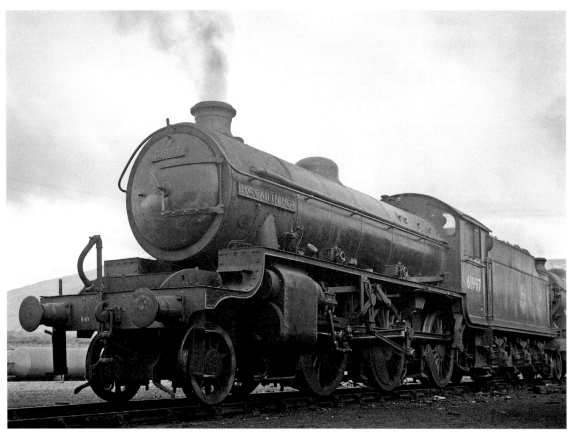

Wednesday 14 June 1950 Pictured here at Fort William shed is the prototype Class K1 2-6-0 locomotive No. 61997 *MacCailin Mor*. Originally designed by Nigel Gresley and constructed at Darlington Works in 1939 as a three-cylinder Class K4 locomotive No. 3445, she was rebuilt at Doncaster Works during 1945. Gresley's successor Edward Thompson used the locomotive as the precursor for a class of two-cylinder locomotives, to be classified K1, which were finally constructed in 1949 during the tenure of Arthur Peppercorn. *MacCailin Mor* would be withdrawn in 1961.

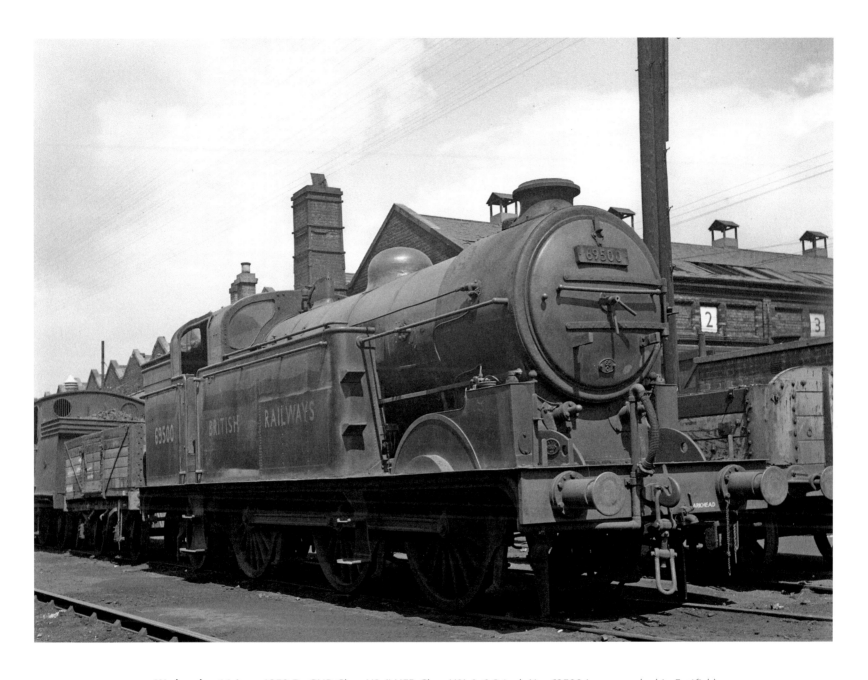

Wednesday 14 June 1950 Ex-GNR Class N2 (LNER Class N2) 0-6-2 tank No. 69500 is seen parked in Eastfield shed. Bearing a 65C shed code, with Parkhead clearly painted on the bufferbeam, she was the product of the NBL during 1920, the class being designed to work suburban trains out of London's Kings Cross station. Originally built with condensing gear, which would later be removed, she was transferred to the Glasgow area during 1927 to work suburban traffic around the city. Spending part of the 1930s based at Carlisle Canal shed, she would finally be allocated to Parkhead shed and be withdrawn from service during 1957.

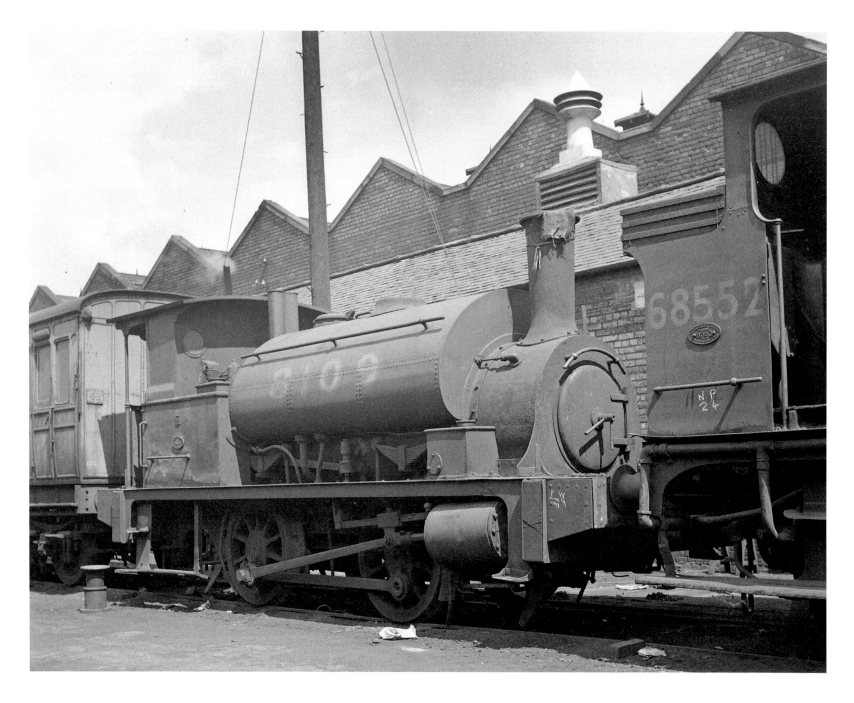

Wednesday 14 June 1950 A true veteran seen here in store at Eastfield shed is ex-NBR Class G (LNER Class Y9) 0-4-0 saddle tank No. 8109. Constructed at Cowlairs Works in 1891 to a design dating back to 1882, she bore various numbers during her life and would be withdrawn in 1954. One example of this class has been preserved, No. 68095, which can be seen at the Scottish Railway Preservation Society Museum at Bo'ness.

Wednesday 14 June 1950 Still bearing its LNER number and company identity, ex-NBR Class D (LNER Class J83) 0-6-0 tank No. 8468 pauses during shunting at Eastfield shed. Built by Sharp, Stewart & Co. in 1901 she would be withdrawn in 1959 numbered 68468.

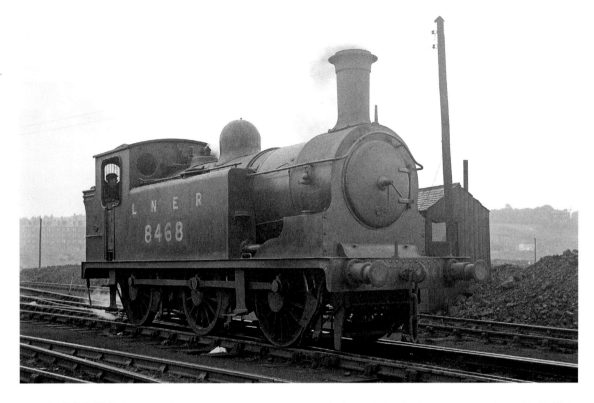

Wednesday 14 June 1950 The thirty-five examples of NBR Class F 0-6-0 tanks designed by William Reid and introduced during 1904, were all constructed at Cowlairs Works. Appearing in batches over a period of fifteen years, with the last examples entering service during 1919, they were classified J88 by the LNER. With a short wheelbase, they were primarily utilised in the docks and harbours that crowded along the banks of the rivers Forth and Clyde. The example seen here in ex-works condition is No. 68335. She entered service during 1909 and would see fifty-three years of service, being withdrawn in 1962.

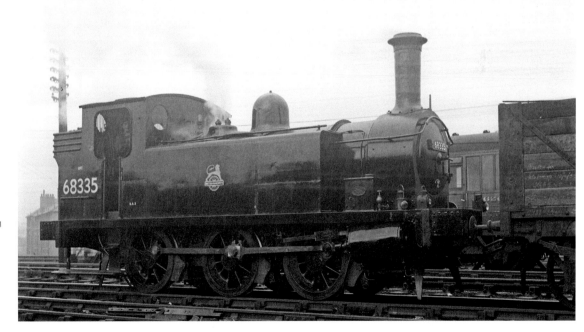

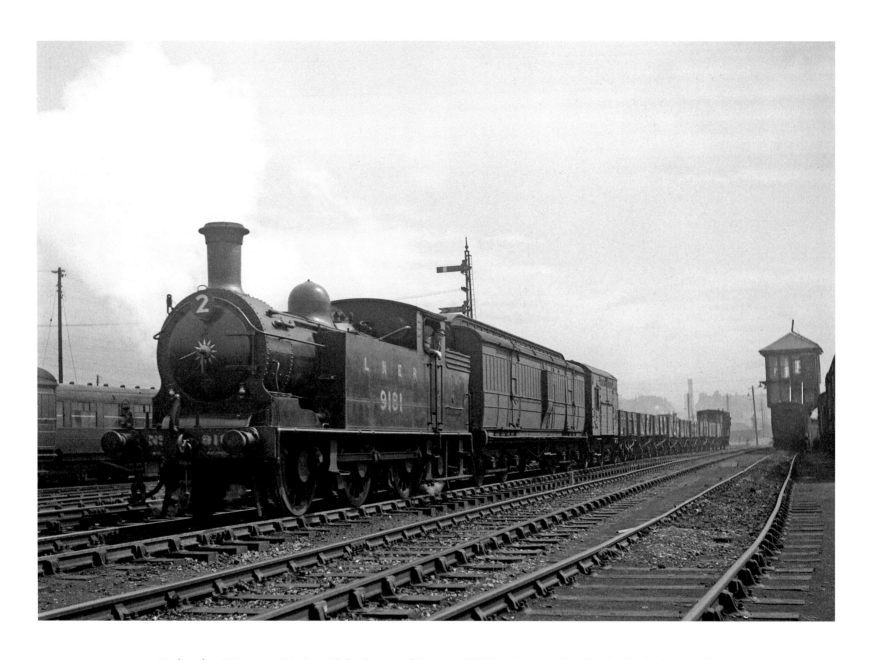

Wednesday 14 June 1950 In beautifully clean condition, ex-NBR Class A (LNER Class N15) 0-6-2 tank No. 9181 is yet to receive its British Railways identity. It does, however, look well cared for by the staff at Eastfield shed, and it still carries its smokebox door decoration. Constructed by the NBL during 1917 she would become 69181 with British Railways and be withdrawn from service in 1962. This locomotive was one of a number of the class based at Eastfield that were allocated to carry out banking duties on the 1 in 42 incline from Queen Street station to Cowlairs utilising slip couplings. She is seen here at the head of a goods train breasting the summit of the bank at Cowlairs. The slip coupling can be seen hanging from a hook adjacent to the locomotive's right-hand buffer.

Saturday 16 May 1959 The powerful lines of ex-NBR Class B (LNER Class J37) 0-6-0 No. 64584 are clearly apparent here. She is in ex-works condition at Kittybrewster shed whilst undertaking some running in after an overhaul at Inverurie Works, bearing a 65C Parkhead shed code. Surprisingly she was withdrawn from service in July 1959, only two months after this photograph was taken. Constructed by the NBL during 1918, she was an example of this very successful class of powerful goods locomotives. They were built between 1918 and 1921 and reached a total of 104 examples.

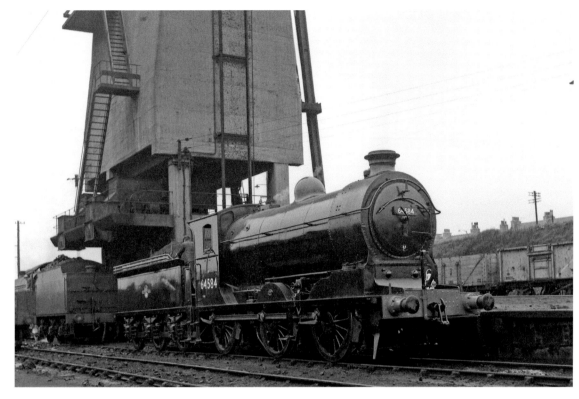

Saturday 16 May 1959 Standing in the yard at Inverurie Works, and in striking ex-works condition, is ex-LM&SR Class 4F 0-6-0 No. 44198, bearing a 67A Corkerhill shed code. She was one of the few St Rollox Works-constructed examples of 1925 that would be withdrawn in 1962.

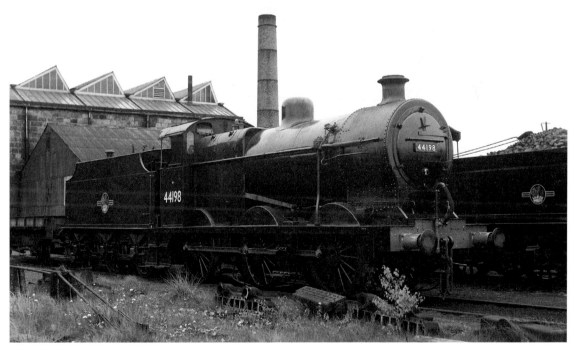

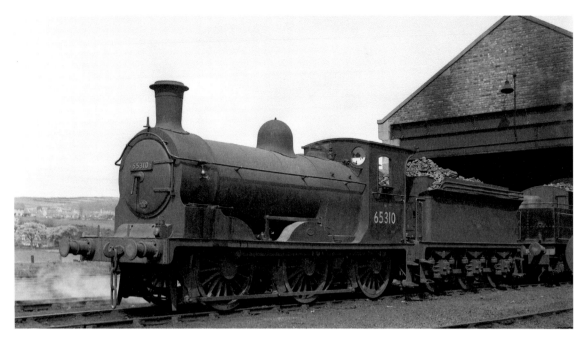

Saturday 16 May 1959 One of the few examples of ex-NBR Class C (LNER Class J36) 0-6-0 to migrate north-east to ex-GNoSR territory was No. 65310, which is seen here at Keith Shed. Built at Cowlairs Works in 1899, she would be rebuilt in the form seen here during 1919 and see sixty-three years of service before being withdrawn in 1962.

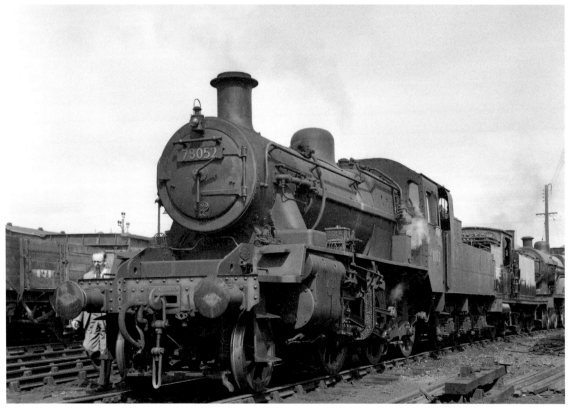

Saturday 16 May 1959 Seen here at Keith shed is BR Standard Class 2 2-6-0 No. 78052, bearing a 60C, Helmsdale shed code. Constructed at Darlington Works during 1955, this locomotive was something of a wanderer in its short life. Originally allocated to Motherwell, she migrated to Helmsdale to work the Dornoch branch for a short time, before spending time at Keith, from where she would work the Banff branch. Finally being allocated to Bathgate, she would be withdrawn after only eleven years of service in 1966.

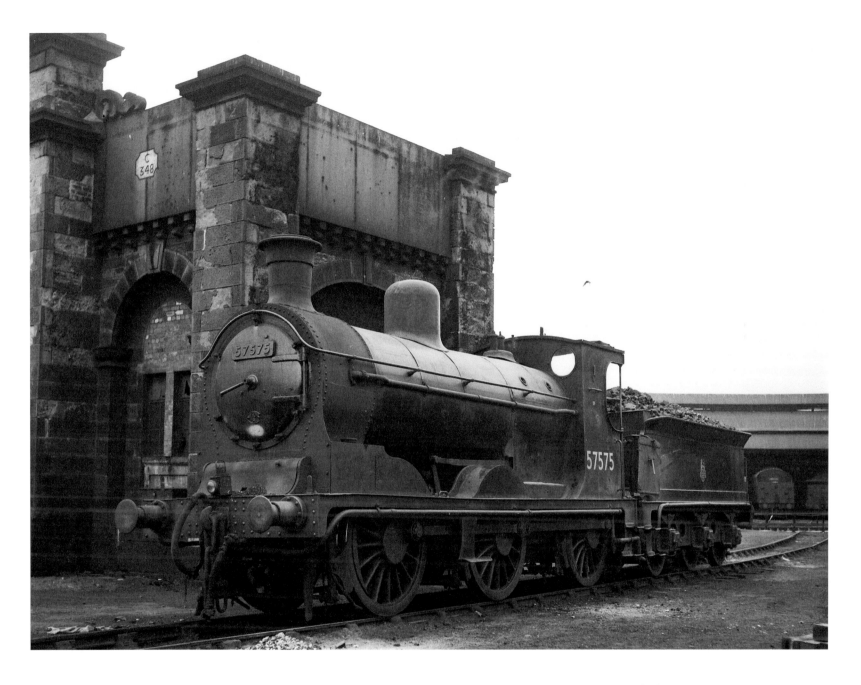

Saturday 16 May 1959 Parked adjacent to the Doric Arch water-storage tower at Inverness shed is ex-CR Class '812' 0-6-0 No. 57575. Built by Neilson Reid & Co. during 1899, she would be withdrawn four months after this photograph was taken in September 1959. A solitary locomotive from this numerous class has been saved for preservation: No. 828, formerly No. 57566, is to be seen at the Strathspey Railway Base at Aviemore.

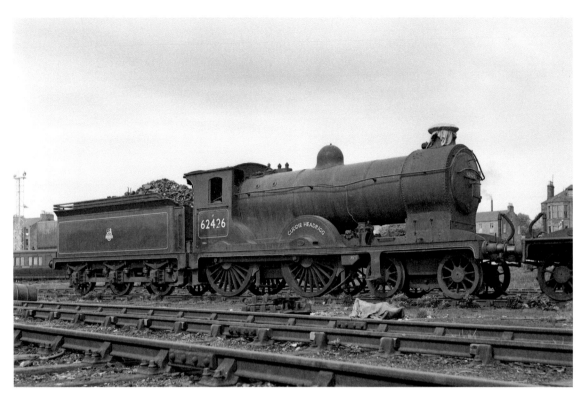

Sunday 17 May 1959 During the late 1950s, sidings at the ex-CR shed at Dundee West became a storage area for redundant locomotives. Amongst the seven present on this day were ex-NBR Class J 'Superheated Scott' (LNER Class D30) 4-4-0 No. 62426 *Cuddie Headrigg* (*above*) and ex-NBR Class L (LNER Class C16) 4-4-2 tank No. 67502 (*below*). The former locomotive had been built at Cowlairs Works during 1914 and named after the ploughman character in the 1816-published Sir Walter Scott novel *Old Mortality*. She would finally be withdrawn during 1960. The latter locomotive was the last of the class to be delivered by the NBL during 1921 and would be withdrawn in 1960.

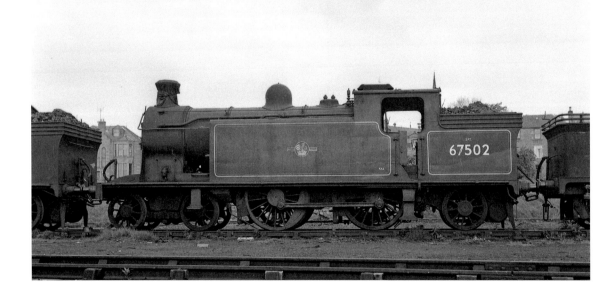

Sunday 17 May 1959 Looking to be in good condition at Dundee Tay Bridge shed is ex-NBR Class B (LNER Class J37) 0-6-0 No. 64619. The final class of 0-6-0 heavy goods locomotives designed by William Reid for the NBR, this powerful class totalled over 100 examples, with the locomotive seen here being built by the NBL and entering service in 1920. She would be withdrawn during 1963.

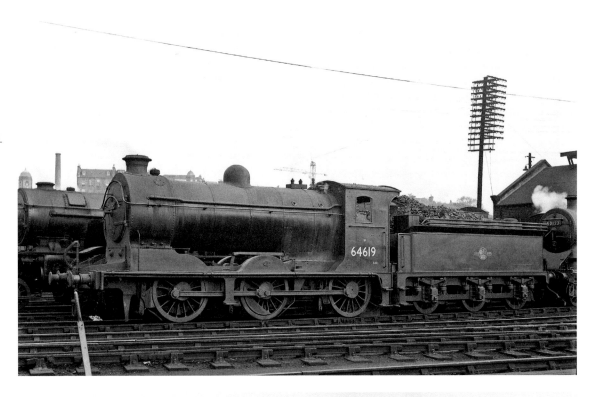

Sunday 17 May 1959 Designed specifically to handle the heavy coal traffic in Fife and the Lothians of Scotland, the thirty-five examples of Nigel Gresley's Class J38 0-6-0 locomotives were all delivered during 1926 from Darlington Works to sheds at Eastfield, St Margarets, Stirling, Dundee, Thornton and Dunfermline. The locomotive seen here, No. 65932, was initially allocated to Eastfield but later moved to be based at Thornton, whose 62A shed code she carries. She would serve for forty years, to be withdrawn during 1966.

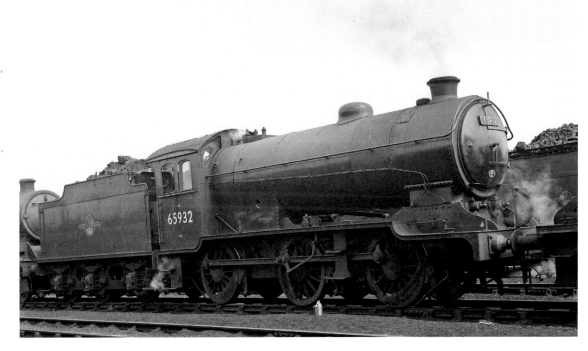

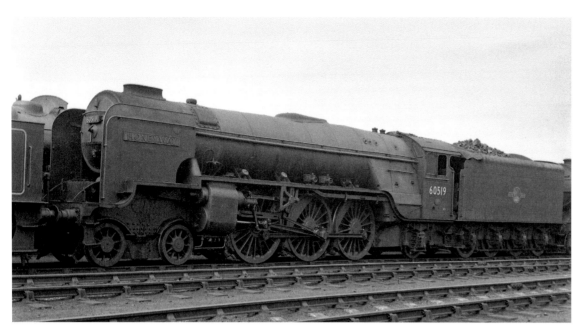

Sunday 17 May 1959 Seen here at Perth shed is ex-LNER Class A2/3 4-6-2 No. 60519 *Honeyway*, which was delivered new to Haymarket shed during 1947 from Doncaster Works. Named after the 1946 Champion Stakes winner, she would have a relatively short working life of only fifteen years before being withdrawn from service in 1962.

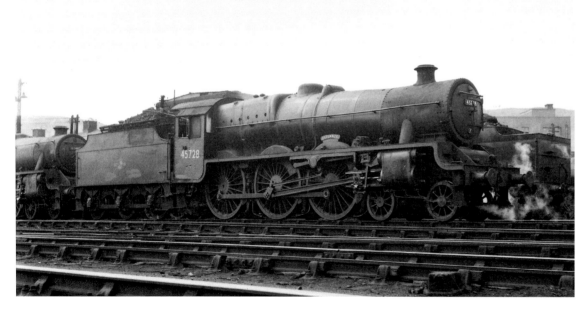

Sunday 17 May 1959 At Perth shed on this day is ex-LM&SR Class 5XP 'Jubilee' No. 45728 *Defiance*. Bearing a 12A Carlisle Kingmoor shed code, she was one of the later examples of the class entering service from Crewe Works during 1936. She is seen here paired with a Fowler-type tender carrying 3,500 gallons of water and 5½ tons of coal. Other members of the class would be paired with more modern Stanier-designed tenders that carried 4,000 gallons of water and 9 tons of coal. *Defiance* would be withdrawn in 1962.

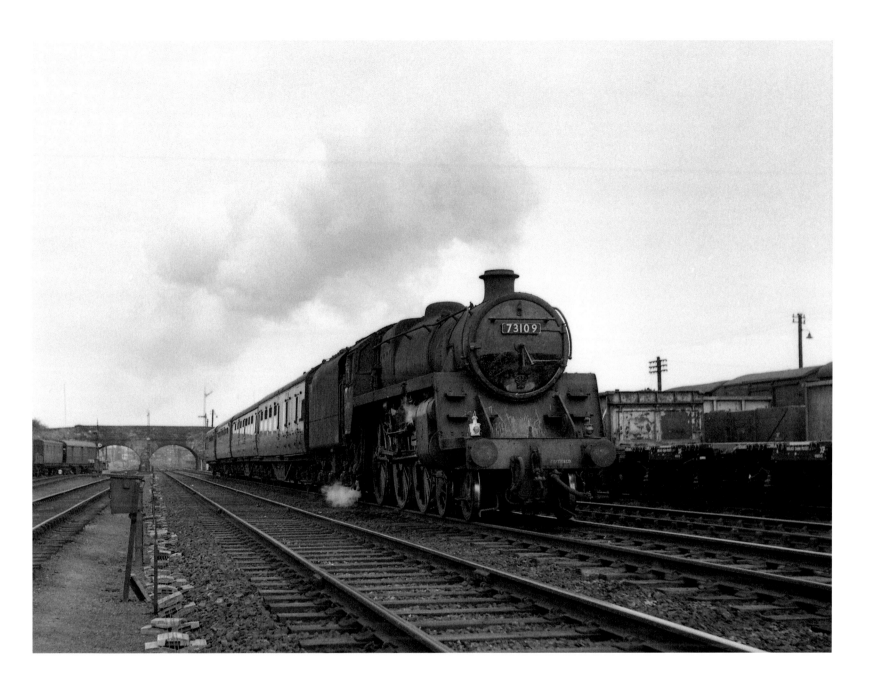

Sunday 17 May 1959 BR Standard Class 5 4-6-0 No. 73109 is seen here accelerating away from Perth with a southbound lightly-loaded express. Constructed at Doncaster Works during 1956 and allocated to Eastfield shed, she would be withdrawn in 1964 after only eight years of service.

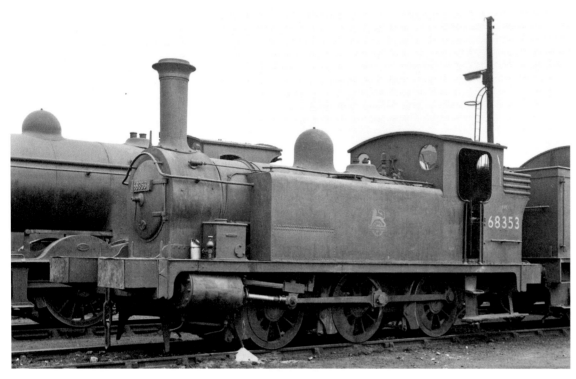

Sunday 17 May 1959 Parked in the yard at Thornton shed is ex-NBR Class F (LNER Class J88) 0-6-0 tank No. 68353. Constructed at Cowlairs Works in 1919, she would be withdrawn during 1962.

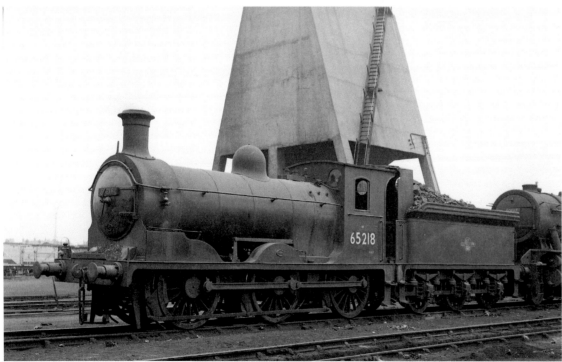

Sunday 17 May 1959 With the modern concrete coaling plant rising in the background at Thornton shed, ex-NBR Class C (LNER Class J36) 0-6-0 No. 65218 is parked ready for her next duty with a fully loaded tender. A product of Cowlairs Works in 1890, she would be rebuilt in the form seen here during 1914 and serve for seventy-two years, being withdrawn in 1962. Note the tender-cab fitting on this locomotive. The Scottish Railway Preservation Society Museum at Bo'ness is home to the only remaining member of the class, No. 65243 *Maude*.

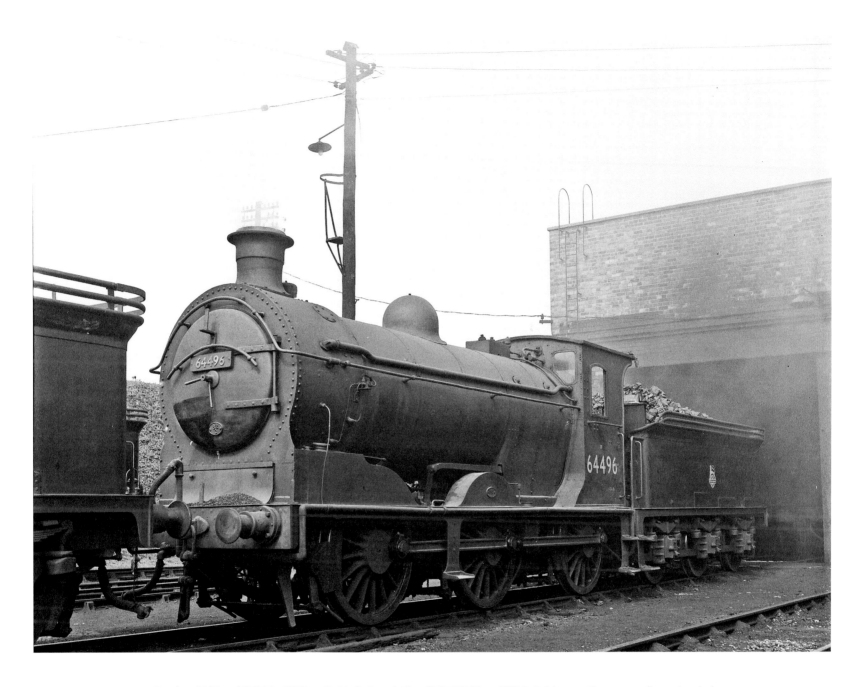

Sunday 17 May 1959 The William Reid-designed Class B (LNER Class J35) 0-6-0 locomotives were all constructed with saturated boilers, but all were rebuilt with superheated boilers by the LNER over a period of many years. Standing at the entrance to Dunfermline shed, with the associated grimy atmospherics, is No. 64496, one of the NBL-constructed examples entering service during 1909, which would be withdrawn five months after this photograph was taken in 1959.

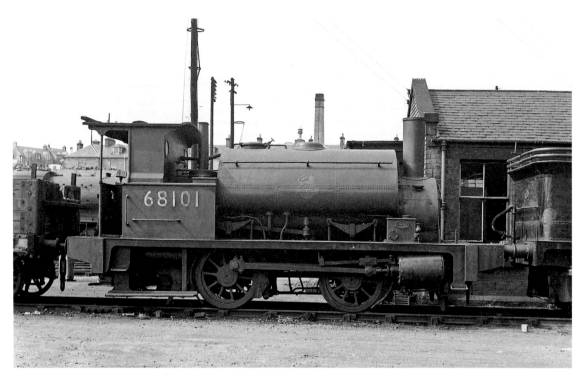

Sunday 17 May 1959 Ex-NBR Class G (LNER Class Y9) 0-4-0 saddle tank No. 68101 is seen here standing in the yard at Dunfermline shed. She had entered service from Cowlairs Works as long ago as 1889 and had borne a succession of numbers with both the NBR and the LNER. At some point she had been fitted with the rather ugly version of a stovepipe chimney seen here. Utilised at Dunfermline Upper station for carriage shunting, she would be withdrawn after seventy-three years of work in 1962.

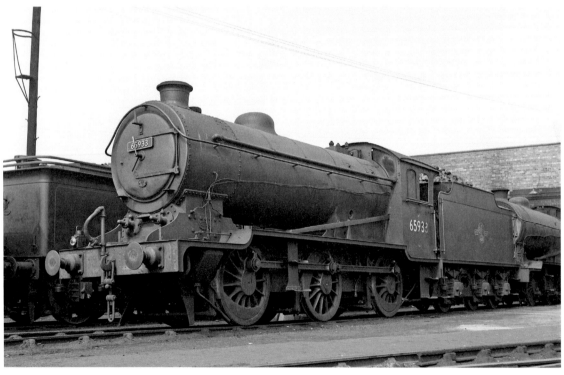

Sunday 17 May 1959 Ex-LNER Class J38 0-6-0 No. 65933 is seen at Dunfermline shed, bearing the correct shed code of 62C. A product of Darlington Works during 1926, she would be withdrawn in April 1965. All thirty-five examples of the class survived and were withdrawn during the 1960s, with the last two examples going for scrap in 1967.

Sunday 17 May 1959 The handsome, well-balanced lines of the ex-NBR Class C (LNER Class J36) 0-6-0s are clearly evident here – No. 65241 looks well-cleaned by the staff at Grangemouth shed. Designed by Matthew Holmes and introduced during 1888, the example seen here entered service during 1891 and would be withdrawn, after seventy-one years, in 1962. It is a great credit to the designer and to the reliability of these locomotives that so many of the class continued working until withdrawal during the 1960s.

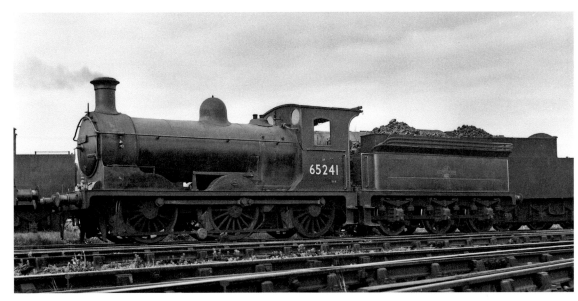

Sunday 17 May 1959 Sitting in the yard at Grangemouth shed is ex-Ministry of Supply Class WD 8F 2-10-0 No. 90766. Built by the NBL during 1945 and numbered 73790 by the War Department, she would be purchased by British Railways during 1948 and initially allocated to Motherwell shed. She would end her days working out of Grangemouth, from where she would be withdrawn in 1962. The NBL constructed a total of 150 of these locomotives between 1943 and 1945, most of which were destined to see service in Europe toward the end of the Second World War. Many remained in Europe after the war, particularly those in Holland, and four examples of the class have been preserved, three in the UK and one in Holland.

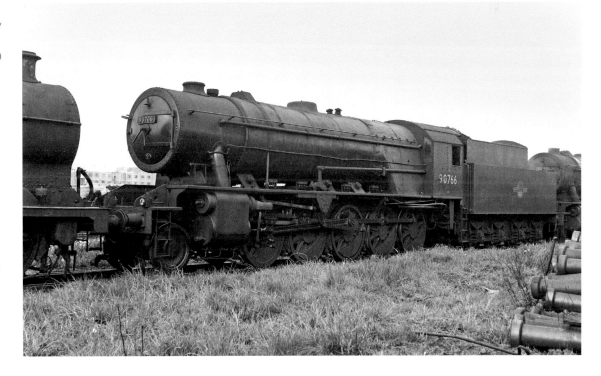

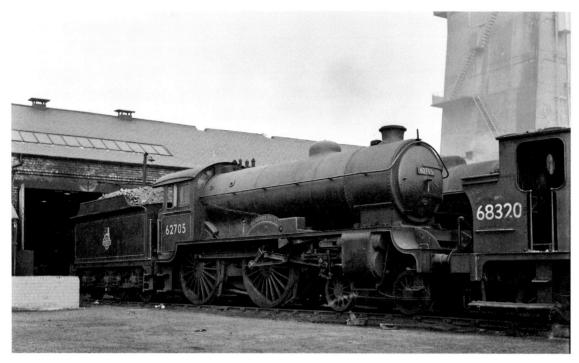

Sunday 17 May 1959 Approaching the end of its working life, ex-LNER Class D49/1 4-4-0 No. 62705 *Lanarkshire* would be withdrawn from service six months after this photograph was taken in November 1959. An early member of this class of three-cylinder locomotives, she entered service from Darlington Works in 1927 and was allocated to Haymarket shed, from where she would initially operate services to Glasgow, Perth and Dundee. One member of the class has managed to reach the preservation scene: No. 62712 *Morayshire* is based at the Scottish Railway Preservation Society Museum at Bo'ness.

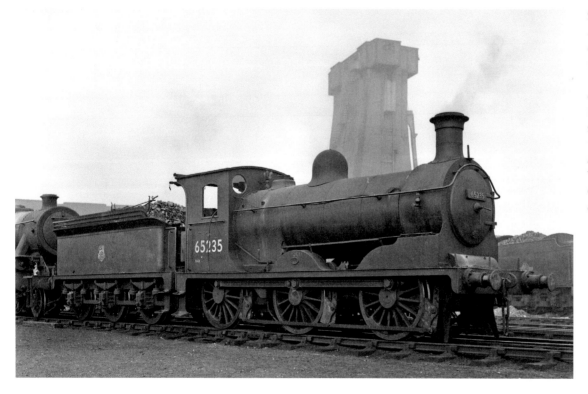

Sunday 17 May 1959 Seen here parked at the western end of Haymarket shed is one of the named ex-LNER Class J36's. No. 65235 *Gough* entered service during 1891 and was one of twenty-five examples of the class requisitioned by the War Department during the First World War, spending time in northern France from 1917 until 1919. She would be withdrawn after seventy years service during 1961. The locomotive was named after Sir Hubert Gough, who commanded the Fifth Army during that conflict.

Sunday 17 May 1959 Ex-LNER Class V2 2-6-2 No. 60882 is looking well cared-for by the staff at St Margarets shed in Edinburgh. This successful class of locomotives designed by Nigel Gresley was introduced during 1936, with the total number constructed reaching 184 examples. The locomotive seen here entered traffic from Darlington Works in 1939, numbered 4853 by the LNER, and was based at St Margarets for her entire working life. She was withdrawn during 1964.

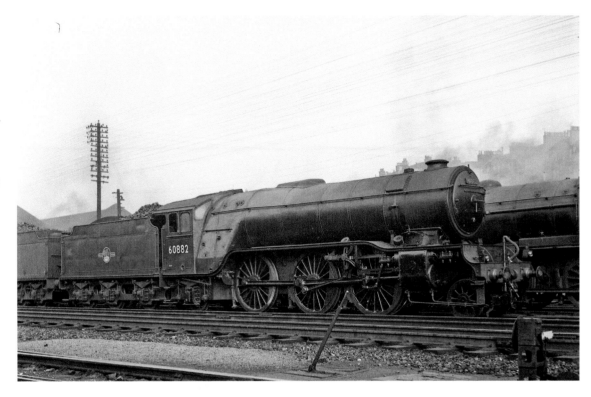

Monday 18 May 1959 Another successful Gresley design of the 2-6-2 wheel arrangement was the Class V1 and V3 tanks introduced during 1930. Initially built to handle suburban passenger traffic around the Scottish cities, approximately half of the ninety-two examples constructed were allocated to sheds in the Newcastle area. All were constructed at Doncaster Works, with the example seen here at Parkhead shed, No. 67679, entering service during 1939. Originally constructed as a Class V1 with a boiler pressure of 180psi, she would be rebuilt in 1953 as a Class V3 with a higher boiler pressure of 200psi. She would be withdrawn from service during 1962.

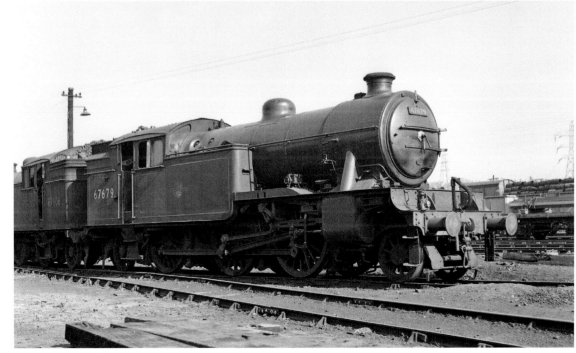

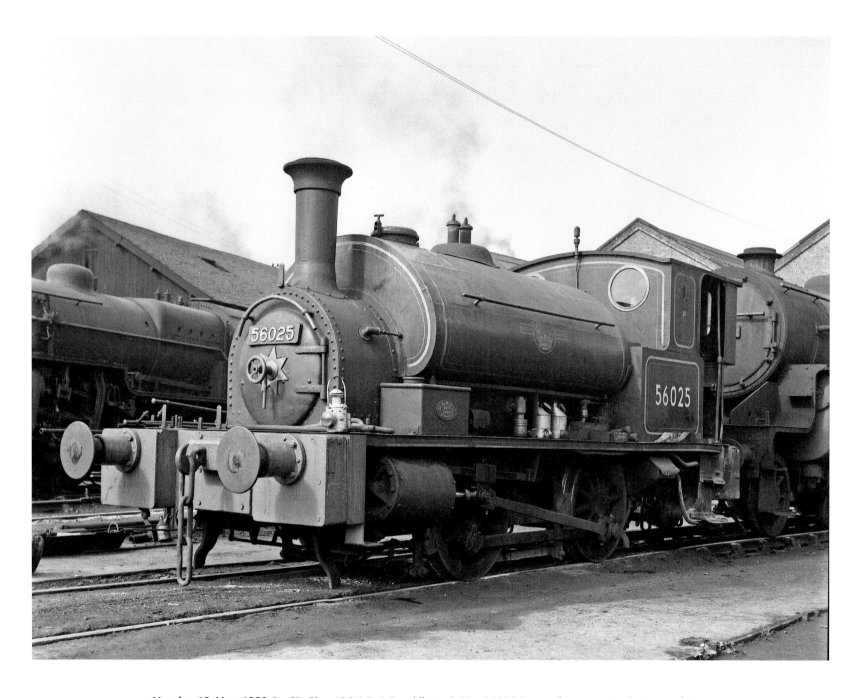

Monday 18 May 1959 Ex-CR Class '264' 0-4-0 saddle tank No. 56025 is seen here pausing between duties. The St Rollox Works shunter was well looked-after and had been outshopped in full lined black livery. One of thirty-four examples of the class built between 1885 and 1908, she was constructed at St Rollox during 1890 and would serve for seventy years before being withdrawn in 1960.

Monday 18 May 1959 A group of well-dressed enthusiasts appear to be comparing notes, whilst behind them, nearing completion of an overhaul at St Rollox Works, is ex-LM&SR Class 5 'Crab' 2-6-0 No. 42910. A Crewe Works-built example of the class, coming into service during 1930, she would be withdrawn in 1963.

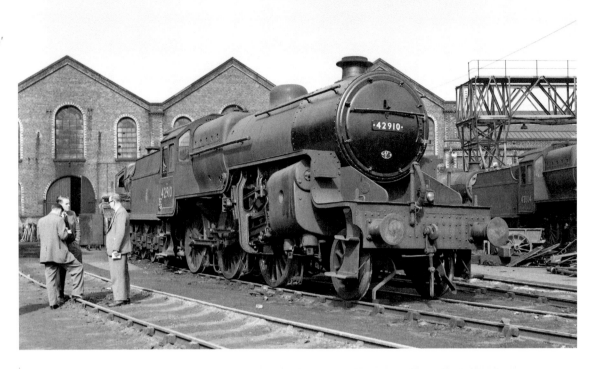

Monday 18 May 1959 Seen here at Eastfield shed after completion of an overhaul is WD Class 8F 2-10-0 No. 90761, looking splendid in ex-works condition. Built by the NBL during 1945 and numbered 73785 by the War Department, she was one of a batch of twenty-five examples purchased by British Railways in 1948. She would be withdrawn from service in 1962.

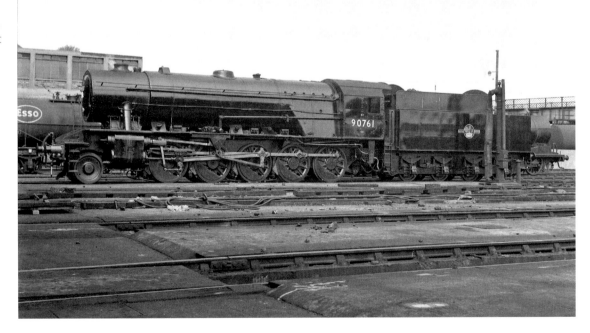

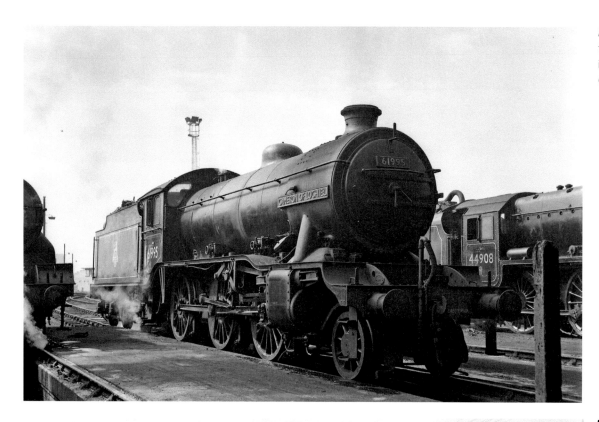

Monday 18 May 1959 Looking well turned-out by the shed staff at Eastfield is ex-LNER Class K4 2-6-0 No. 61995 *Cameron of Lochiel.*

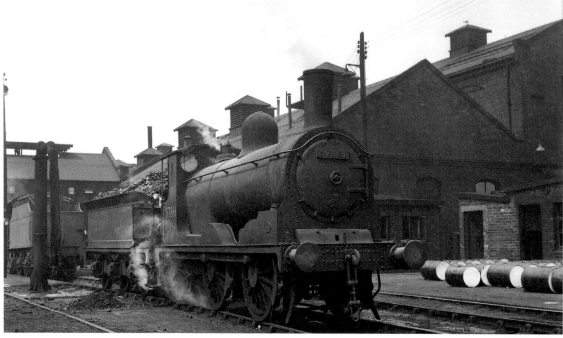

Monday 18 May 1959 Seen here at Polmadie shed sporting a stovepipe chimney is veteran ex-CR Class '294' 0-6-0 No. 57361. Built at St Rollox Works in 1892, she would be withdrawn during 1959, having given sixty-seven years of service.

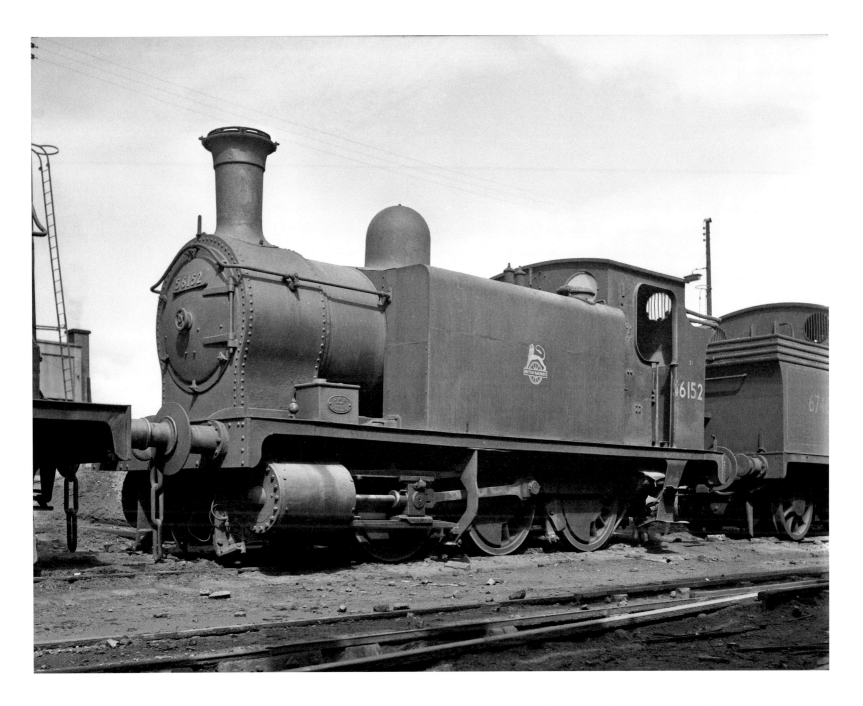

Monday 18 May 1959 Out of service and officially withdrawn two months earlier, ex-CR Class '498' 0-6-0 tank No. 56152 is seen here at Eastfield shed prior to going for scrap. Constructed at St Rollox Works during 1912, she spent much of her working life allocated to Grangemouth shed.

Monday 18 May 1959 BR Standard Class 4 2-6-4 tank No. 80026 is looking very smart at its home shed, Polmadie, in Glasgow. An example of the 1951-built Brighton Works members of the class, she would be withdrawn from service during 1966. Between 1951 and 1957,155 examples of the class were constructed by Brighton, Derby and Doncaster Works.

Monday 18 May 1959 At Corkerhill shed in Glasgow, BR Standard Class 4 2-6-0 No. 76092 waits to leave for its next duty. Constructed at Horwich Works during 1957, she would be withdrawn in 1966 after only ten years of service. A total of 115 members of the class were built at Doncaster and Horwich Works between 1952 and 1957.

Monday 18 May 1959 Ex-CR Class '439' 0-4-4 tank No. 55235 is seen here at Corkerhill shed. Allocated there for many years, she was a St Rollox Works-built example from 1922 that would be withdrawn during 1961. The class consisted of batches of locomotives constructed between 1895 and 1925, which had a number of variations: condensing gear was fitted to the early examples for working the Glasgow Low Level lines, while later examples would have larger water tanks and some would suffer the final indignity of having stovepipe chimneys fitted. During LM&SR days, a number of the class were tried out at English sheds but all were eventually returned to Scotland. The one member of the class to be preserved, formerly British Railways No. 55189, ex-CR No. 419, is currently undergoing a major overhaul at the Scottish Railway Preservation Society's Works at Bo'ness.

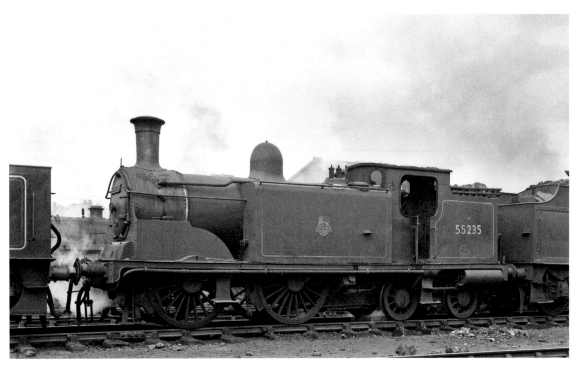

Monday 18 May 1959 A long-term resident locomotive of Polmadie shed, ex-CR Class '498' 0-6-0 tank No. 56159 is in a filthy condition, with her number barely visible. A 1918-built member of the class, she would be withdrawn during 1962.

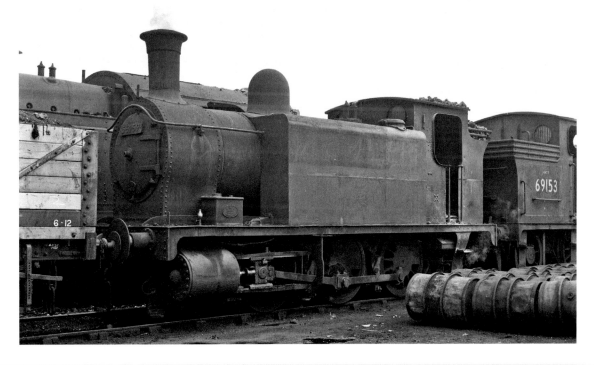

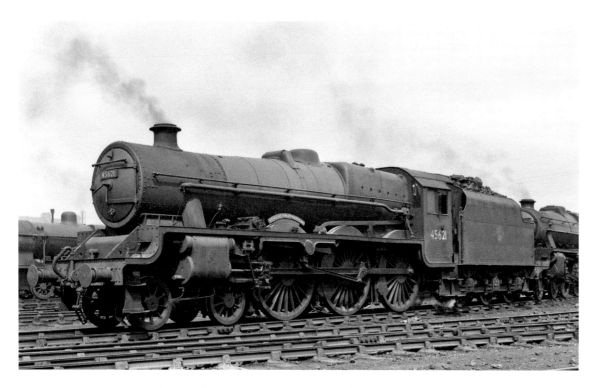

Monday 18 May 1959 Corkerhill-allocated ex-LM&SR Class 5XP 'Jubilee' 4-6-0 No. 45621 *Northern Rhodesia* is seen here at her home shed, 67A. Constructed at Crewe Works in 1934, she would be withdrawn during 1962.

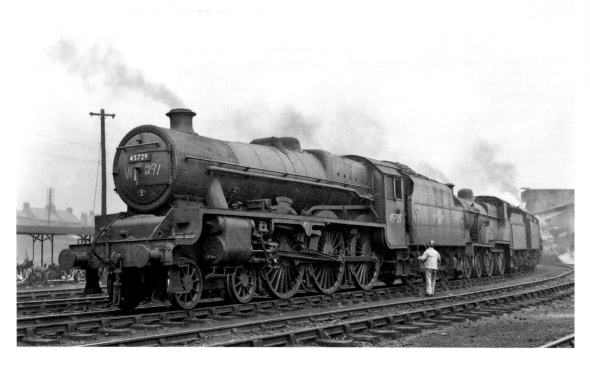

Monday 18 May 1959 Ex-LM&SR Class 5XP 'Jubilee' 4-6-0 No. 45729 *Furious* is also seen at Corkerhill shed. Bearing a 12A Carlisle Kingmoor shed code, she was also a Crewe Works-built example, entering service during 1936. She would be withdrawn in 1962.